IMAGES
of America

SHASTA
NATION

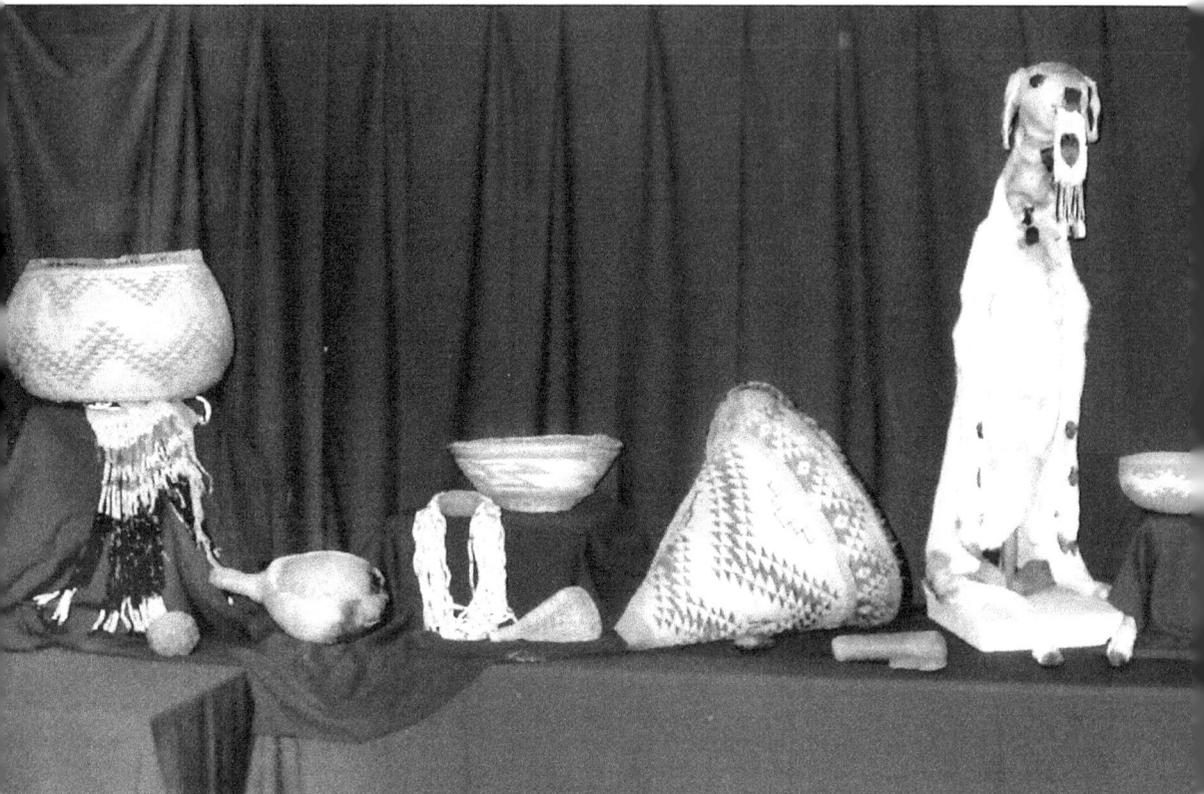

This white deer skin is about 100 years old and is decorated with red pileated woodpecker scalps. It belonged to Betty Hall's great uncle Edward Wicks and is the only white deer skin owned by a Shasta Indian still in existence. The baskets all have Shasta Indian designs. All of these items are on display at the Fort Jones Museum. (Courtesy Mary Carpelan and the Fort Jones Museum.)

ON THE COVER: Mary Ann Bender was born in Quartz Valley. She was Jennie Wicks's sister. Shasta Indian Jim Bender came from McCardle Flat on the Sacramento River to Tyee Jim's village looking for a bride. Jim Bender courted and married Mary Ann according to Shasta Indian custom. They lived near Yreka on the Julius Bender Indian allotment and raised a large family there. This photo was taken at Graveyard Gulch. (Courtesy Fort Jones Museum.)

IMAGES
of America

SHASTA
NATION

Betty Lou Hall and Monica Jae Hall

ARCADIA
PUBLISHING

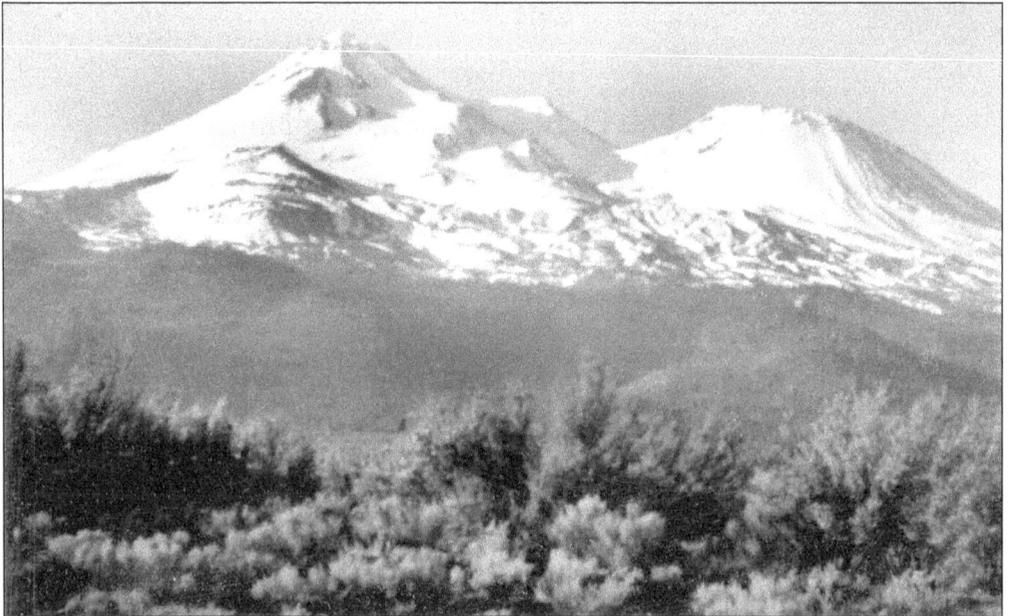

WAKA! (Mount Shasta) is the sacred mountain of the Shasta Indians and other surrounding tribes near and far. The Shasta Indian story of our own creation begins on WAKA. God stepped on top of the mountain and placed the people at the valley floor. Shastas only went above the tree line to die. This photo was taken c. 1980. (Courtesy Betty Hall.)

CONTENTS

This book is dedicated to the memory of Robert Roy McCallister, born May 14, 1940, in Yreka and died January 26, 2001, in Oro Fino.

Anna Brodmerkle said it best when she wrote this application letter to the University of Idaho:

My Mother's Uncle, the late Robert McCallister, had the most influence on my life, as is the Cahuilla and Shasta tradition (Indian families stay very closely knit). Uncle Butch, as I called him, taught me how to ride and care for a horse. When I was a child he gave me my first pony, then my first horse, and my best horse when I was an adult. He taught me to "Be Brave." To try things that seem impossible, so that at the very least I could walk away knowing I had put my best effort into it. He taught me to work hard, knowing hard work is its own reward. He was sincere in all he did, and he taught me to love life and be happy—no matter what. He believed I would make a good veterinarian. And because he believed in me, I believe in myself. That is why I'm in college studying pre-veterinary medicine. And that is why I still raise horses.

—Anna Brodmerkle, July 2000.

ACKNOWLEDGMENTS

We would like to thank the members of the Shasta Nation who so generously shared their pictures and stories to make this book possible. We thank the Fort Jones Museum, and especially museum manager Cecilia Reuter, for all their support. We thank our photo contributors: Caraway George, Patricia McCallister, Sharon McBroom, Alberta Skillen, Pat Martin, Charlie and Pam Hayden, Don Boat, Siskiyou County Historical Society, Mary Carpelan, Jim Prevatt, Richard Sargent, Harry Lake, Jenn Hidalgo, Glenn Hall, Bernita Tickner, Katherine Beatty, Jim Falkoski, Martha Gomes, Bonnie Bailey, Jeanine Griggs, Virginia Thom, Peggy Johnson, Henry McBroom, Virgil Nesbitt, Linda Navarro, Victor Navarro, Brenda Brodmerkle, Annie Brodmerkle, Stephanie Carpelan, Tracy Hall, Monica June Hall, Janet Josh, Wayne Bartley, Joan Webster, Johnnie McLaughlin, Angie Brodmerkle, Jessica Brodmerkle, Rod Eastlick, Marjorie Brooks, *Fort Lewis Sentinel*, Nancy Streeter, and Sharon Iverson. We thank Nina Cossey for her photos and proofreading, and artists Theresa Naylor and Mary Carpelan. Special thanks go to Gail Jenner who has given us such support and encouragement in this venture. And special thanks go to our husbands, Roy Hall Sr. and Roy Hall Jr., who have eaten cold dinners and had to listen to our brainstorming and have sorted photos and made photocopies into the night. We love you all and couldn't have created this book without every one of you.
—Betty and Monica

INTRODUCTION

This is the history of the Shasta Nation as told by the Shasta people through Betty Hall. She has spent her life recording and verifying the Shasta oral history with documents, photos, and interviews to assure accuracy and validate the true oral tradition. Native peoples still use that oral tradition today to pass their history on to future generations.

These are images of the Shasta Indians who inhabited the Rogue River drainage toward the coast and Northern California. The Shasta believed WAKA put them here to care for the land. All that walk, fly, or swim are sacred and are here for the use of the people.

The Shasta's government consisted of a head chief and sub-chiefs. The chiefs settled disputes, and had to be wealthy. They had to see that enough food was put away for winter. Medicine people did the Salmon Calling. They prayed the fish a safe journey, and threw epos (a flowering bulb that was a staple food) on the water. For three days the salmon run was allowed to pass to ensure a bountiful harvest the next year.

The Marriage Wheel was a unique system. Rogue River Kahosadi could marry into the Kamatwa, and counter-clockwise around the geographical area of the Shasta Nation, keeping marriages in the same area seven generations apart. Chiefs arranged marriages with other tribes for political strength.

Grand Conclaves were held at Medicine Lake, 25 air miles northeast of Mount Shasta. Indians came from the West, Canada, and the Plains. Young men went on vision quests and competed in sports. This trade fair was held in the fall and it was a gathering area for obsidian.

Old Man Ruffy (a.k.a. Frank Ruffy) saw the first white man in the valley. Stephen Meek came in 1826 for two weeks of trapping, then left. In 1836, he came back with McKay and stayed all winter in Oro Fino. They trapped all the beaver they could carry and left.

The miners discovered gold in March 1851 in Thompson Dry Diggings (Yreka) and in Scott Bar. The richest area was right in the heart of the Shasta Nation. Suddenly the area was filled with thousands of miners all fighting to claim their share of the rich gold-filled rivers and mountains. They muddied the steams and ate what deer they didn't frighten away. When the starving Shasta people were pushed to desperation, they fought back.

Commissioner Reddick McKee made a treaty with the Karuk at Somes Bar, California, on October 6, 1851, which was a supplement to the treaty made with the Yurok and Hoopa tribes. McKee camped at Clear Creek on the Klamath River. George Gibbs, a linguist, recorded that the language changed to Shasta when they left Clear Creek and traveled up the river.

McKee's party negotiated a treaty with the Upper-Klamath, Shasta, and Scott's River chiefs. Three thousand warriors came and camped at Sharps Gulch. Thirteen Shasta chiefs signed the treaty with an X mark. A reservation was set aside. McKee stated that Shasta from the Upper-Trinity would be brought in.

After the signing on November 4, 1851, a feast was prepared. Poison was put in the beef and bread. Chief Ida-kar-i-wak-a-ha and Chief SunRise, Got-a-uke-Ek-su, signed the treaty, but did not eat. Tyee Jim was a teenager and did not partake either. They buried the dead along the trails for weeks. About 170 warriors fled to the mountains. Vigilantes swept through the Shasta Nation, burning every village and slaughtering the people. They threw the dead and dying on fires.

Tyee Jim fell from, and was dragged by a buggy in 1905. Betty Hall's grandfather, Fred Wicks, took him to the Wicks ranch. Clara Wicks cared for him, but he died three days later. Fred and Clara heard the story of the poisoning first hand and in the oral history tradition. The words never changed, so as to preserve the truth of events.

Fort Jones was established in 1852. The soldiers gathered up the Shastas to march to reservations. White men that had Indian women went to the fort, drew their guns, and took their women home. Edward Wicks took Jennie home and Betty descends from them.

Some say the poisoning never happened, but in the 1852 Indian Census there are 27 Shastas in Siskiyou County, and it has been proven through tracing lineages of the Shasta Nation that the members descend from the 30 women and 5 couples who were alive in 1851.

Shasta Indians fought, and died, in the Civil War. Andrew George, a Catawba Indian soldier in Captain Smart's unit, married Polly, daughter of Shasta Chief Ida-kar-i-wak-a-ha, which means "from the coyote's country far away." When Polly died in childbirth at Jefferson Barracks in Missouri, leaving two children and a stepchild, General Halleck sent word to Chief Ike, as he was called, to come. Ike was 6 feet, 10 inches tall and too large to ride a horse, so he walked and his wife, Mary, rode a horse to Jefferson Barracks. They stayed all winter. Andrew George died and Ike, his wife, Mary, and grandchildren left Missouri for California on April 7, 1866. The military gave Ike a large draft horse to ride and he returned with the remains of 28 Shasta Indian soldiers who died fighting for the Union in April 1863 at the battle of Patterson, Missouri. The burial site is on the Upper Klamath River and they were given a full military burial. In 1873 Chief Ike was one of the warriors who stayed to fight with Captain Jack at his stronghold at the end of the Modoc Wars, and was captured with him. Ike was sentenced to Alcatraz Prison for life.

Around 1900 the Shasta were given some land allotments in the worst places. The government agents convinced them to sell their land for pennies, and then they would get better land. The Indians sold the land, but no new land was allotted.

On June 16, 1939, the Quartz Valley Indian Reservation was created for the benefit and use of the Upper-Klamath and Shasta Indians and their descendents. Betty Hall's home was the first one built there. They moved in when she was 4, and at 14 she kept the minutes and records for the Quartz Valley Reservation.

U.S. government Indian agents accepting applications for allotments decided that any Shasta with a white spouse could not be a member. This was illegal and kept most Shastas from receiving allotments. The Karuk claimed to be Klamath, and the agents accepted those applications.

Roy Hall received an assignment of land in 1957, but the reservation was terminated in 1967. The Shasta Nation filed a petition for federal recognition in 1982, and in 1983 Quartz Valley Reservation was reinstated, as it was before termination. When Roy went to the reservation he was told he could not be a member. One Karuk family sent the list of only their family members as being present and eligible for membership, and the Bureau of Indian Affairs accepted that list. The Shasta have sent thousands of letters to senators, congressmen, and state and federal representatives, but are put off or ignored. Over 1,000 letters were sent to Senator Diane Feinstein in support of Shasta federal recognition. So far no response has been received.

Despite the government's best efforts to displace, discredit, and dispose of the Shasta Nation, it has survived and thrives today, and according to the Bureau of Indian affairs, "Current federal Indian policy dictates that our nation must maintain their protection, welfare, and sovereignty into perpetuity."

What is truth?

One

THE KLAMATH RIVER AND ROGUE VALLEY

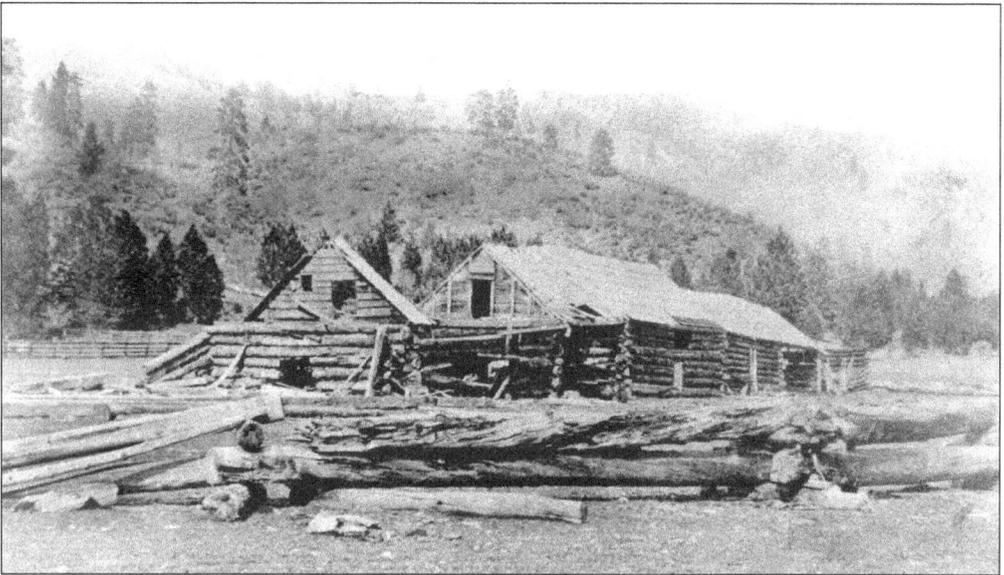

Fort Jones in Scott Valley, California, was established October 16, 1852. It was abandoned June 25, 1858, and is shown above many years later. After the genocide, described in the introduction to this book, soldiers rounded up stragglers. They were kept in open pens. Settlers gave clothing but many Indians died. Miners who had Indian women went to the fort, drew their guns, and took their women home. The Shasta Nation descends from these women. About 100 Shastas were marched to Grand Ronde, and Siletz Reservations in Oregon, never to return. Some of their descendants became members of the Confederated Tribes of Grande Ronde and Siletz. (Courtesy Fort Jones Museum.)

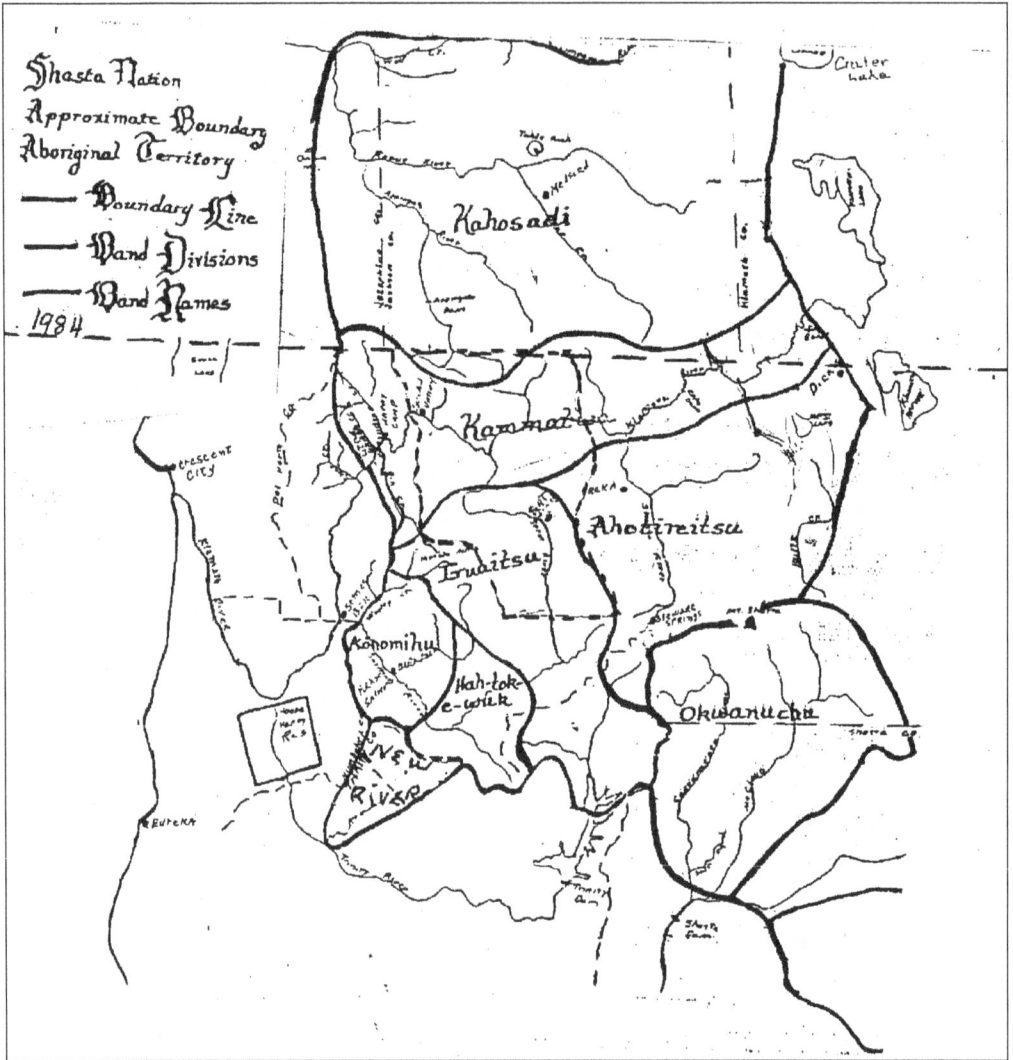

This map shows the approximate aboriginal territory of the Shasta Nation. Starting at Crater Lake, Oregon, it goes westward following the north ridges of the Rogue River drainage to just past Wolf Creek. It then runs south to west of Indian Mary Campground, continuing west of Illinois Valley, over the mountains to Clear Creek on the Klamath River. Crossing the Klamath River, it goes southeast to the summit separating Wooley Creek from the Klamath, following the ridge to Salmon River. Then it goes south to the Trinity County line, turning east to the New River drainage, then on to the east side of Trinity Lake at Litton Ridge. Continuing on to Salt Creek on the Sacramento River, it takes in McCloud River and Taritsi Creek drainages. Turning north, it goes easterly of Butte Valley, then northwesterly above Dorris to Mount McLaughlin and to Crater Lake. Shasta Nation is a diverse and beautiful country. (Courtesy Shasta Nation.)

Chief John, one of the 175 warriors who escaped to the mountains, left Scott Valley after the genocide. He moved to the Applegate River and was called Chief Applegate John. He was a leader in the Rogue River War of 1853 and the last to lay down his gun. He tried to escape from Grand Ronde, so he and his son Adam were sent to Alcatraz Prison for a time. He is buried on the Siletz Indian Reservation. (Sketched from a photograph by Mary Carpelan, courtesy Mary Carpelan.)

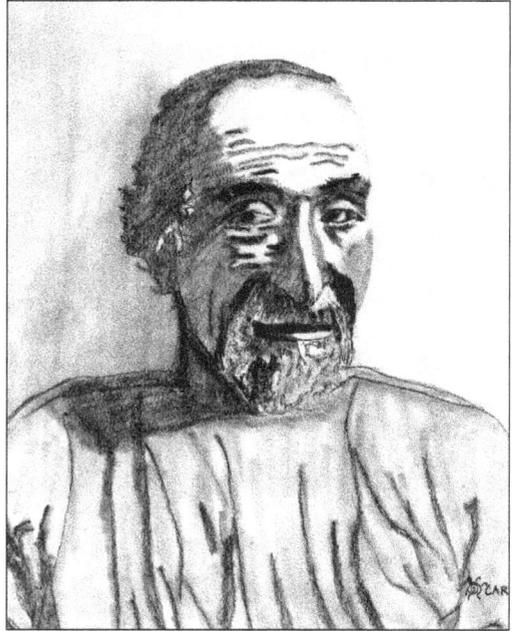

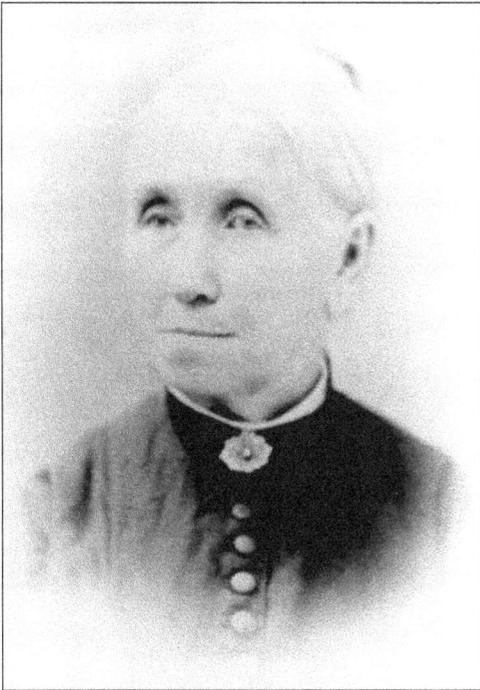

Mary (John) Campbell, at left, was the daughter of Chief Applegate John. She was one of approximately 30 women who were rescued from Fort Jones by miners in 1852. Her husband was John Campbell, and their home was near Shackleford Creek, in Quartz Valley. Alberta (Alford) Skillen of Etna is her descendent. Sarah (Campbell) Alford, at right, was the daughter of John Campbell and Mary John. She married Austin Hanley Alford and they made their home in Quartz Valley near her parents. They had twin sons, Albert and Alfred Alford. Albert is Alberta (Alford) Skillen's father. (Both courtesy Alberta Skillen.)

Lucy Jim was born about 1844, and was sister to Tyee Jim, the last of the Shasta chiefs. Chief Big Jim was their father and he died during the poisoning of the Shasta Indians, after the signing of the peace treaty, on November 4, 1851. Lucy witnessed the genocide of the Shasta people. She lived on Tyee Jim's Indian land allotment, then she lived with the Charlie Wicks family at their ranch on the Scott River. When Charlie bought the Pearl Eastlick place in Mugginsville, Lucy went with them. Betty Hall's parents lived across the road. Lucy saw Betty and held her in her arms. Betty was two weeks old when Lucy died. Betty has always felt a very great affinity toward Lucy. Betty's and Lucy's lifetimes overlapped, so the genocide isn't ancient history. It touches us all. (Courtesy Betty Hall.)

Lucinda Pitts was the daughter of Sarah Josh, of Shasta/Modoc lineage. Sarah's mother, Mary, and aunt Annie were Chief Josh's daughters. The girls were captured on the Upper Klamath River by Modocs. They escaped from a boat by edging closer to the western shore of Klamath Lake, then running for freedom. Mary was captured again by Modocs. They blinded her by putting a hot object on her eyes so she wouldn't run away again. Annie found her and led Mary home. (Courtesy Janet Josh.)

Valentine Griffith, a Rogue River Shasta Indian, married Lucinda Pitts. The Griffith homestead was located north of Iron Gate Dam on the Klamath River. They raised seven children: twin sons David and Ernest and daughters Minnie Blowers, Ruth, Mary Cannon, Agnes Potter, and Alameda. (Courtesy Janet Josh.)

13

Agnes Griffith married Ellis Potter who worked on the Iron Gate Dam. In 1985 Mary Cannon, Agnes, and her son Alan talked about Indian Mary, daughter of Chief Joe, and Mary's daughter Lillian, who lived near Grants Pass. In the summer they would walk over the Siskiyou Mountains to the Klamath River to visit. They stayed with Agnes's family. Lillian had a beautiful singing voice. Agnes died October 15, 1991, at the age of 88. (Courtesy Janet Josh.)

Minnie Florence Griffith was born on the Griffith homestead on the Upper Klamath River. The family had to be self-sufficient. They raised their own food, had cows, pigs, horses, and chickens. They hunted and fished to complete the food stock. Right up behind the home was the location of what is known as the "Cave Fight" in the 1850s. Miners captured two Indian women, who later escaped and went home. The miners chased them and were killed. An alarm went out among the miners and a cannon was brought in to blast the cave that the Indians hid in (see pg. 16). (Courtesy Janet Josh.)

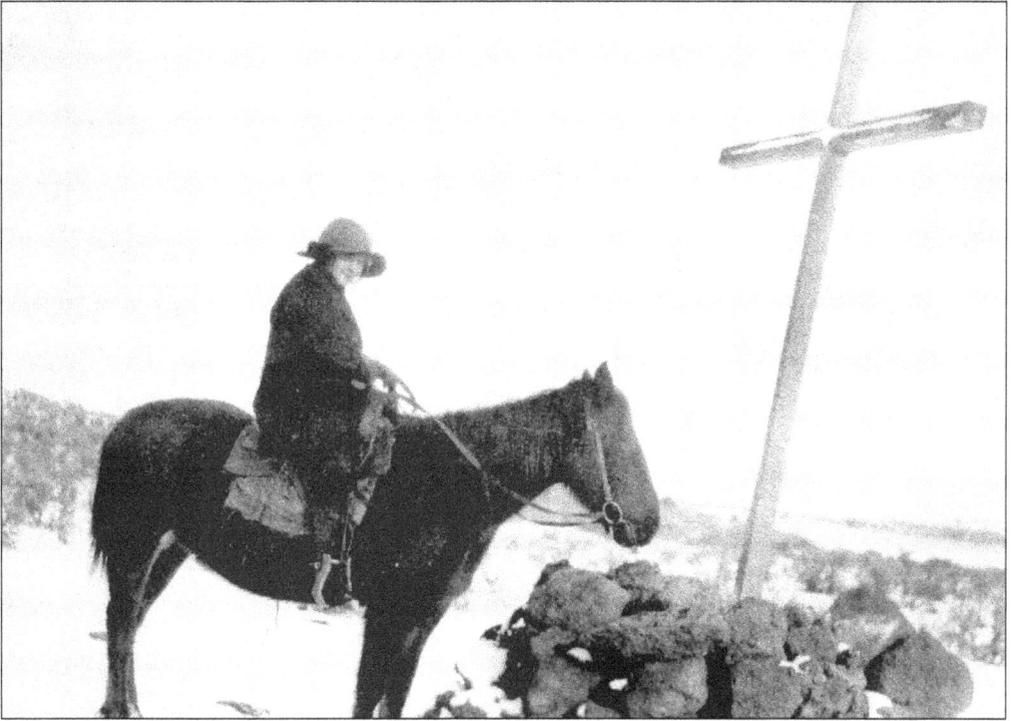

Minnie (Griffith) Blowers rode her horse from the Griffith homestead on the Upper Klamath River to General Canby's Cross, at Captain Jack's Stronghold during the Modoc Wars. It was a long way, about 65 miles. Snow was on the ground, and that is cold country. Minnie was Janet Josh's grandmother. Janet came to visit Betty on May 29, 2004. (Courtesy Janet Josh.)

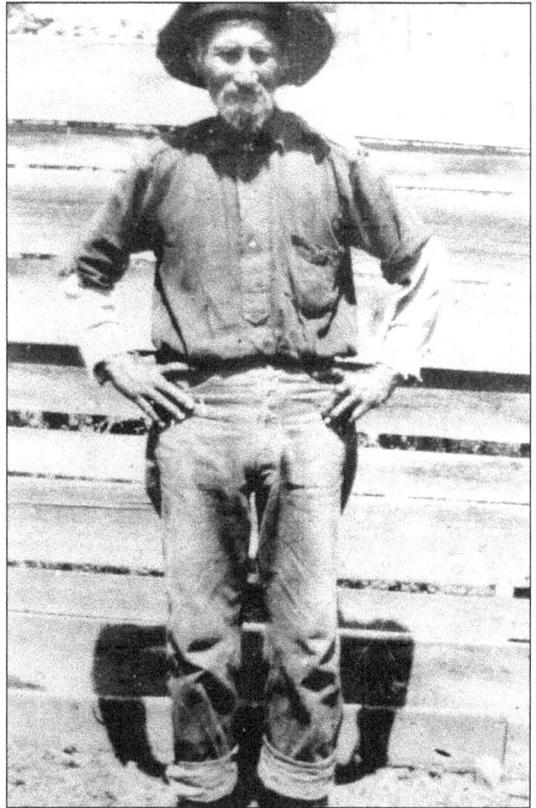

When Julius Bender, shown at right, died in 1967, the Bender allotment south of Yreka was claimed, and received, by people who were not related to him. Caraway George, great grandson of Chief Ida-kar-i-wak-a-ha, one of the signers of the treaty of 1851, petitioned to have the case reopened. The U.S. Department of the Interior allowed a new hearing and Caraway proved his direct lineage from Mary Ann Bender, Julius's mother. The allotment was awarded to him. On appeal, the judges reversed the award, and stated that the case should never have been reopened. (Courtesy Betty Hall.)

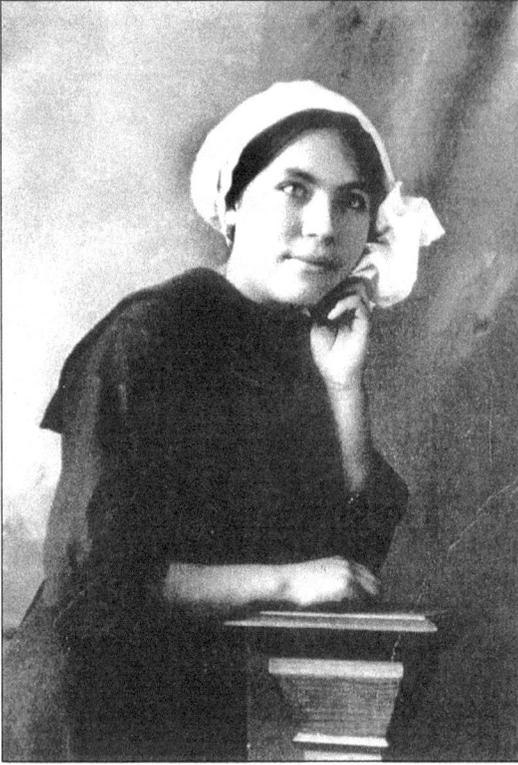

Mary Cannon, shown at left c. 1918, lived at Gazelle, California. She told Betty about the "Cave Fight" in the 1850s when miners captured two Indian women who escaped and went home. The miners chased them and were killed. The alarm went out and a cannon-type gun was brought in. They blasted the cave the Indians were in. When the captain from Fort Jones heard about this, why the miners were attacking the Indians, he refused to assist the miners and left the area. (Courtesy Janet Josh.)

Mary Griffith Cannon was born August 9, 1898, at Pokegama Flats on the Klamath River. She died January 4, 1989. When Betty Hall knew her, Mary would sit beside her sister Agnes Potter and smile a lot. She could not hear, but at times she would say, "Whatever Agnes says is truth." and she was adamant about it. In her old age she was still beautiful; so was Agnes. (Courtesy Janet Josh.)

Old Beans from Hamburg was a cousin to Sargent Sambo, the last full-blood Shasta Indian, who was interviewed by many ethnographers. Old Beans is wearing an ornament of dentalium shells in his nostril. This was only worn during ceremonies. Mandy McCallister said he would sometimes be ornery and mean so the Indians would lock him in a sweat house (unheated) for a few days. When he promised to be nicer they would let him out. His headstone in Hamburg reads BEANS. (Courtesy Betty Hall.)

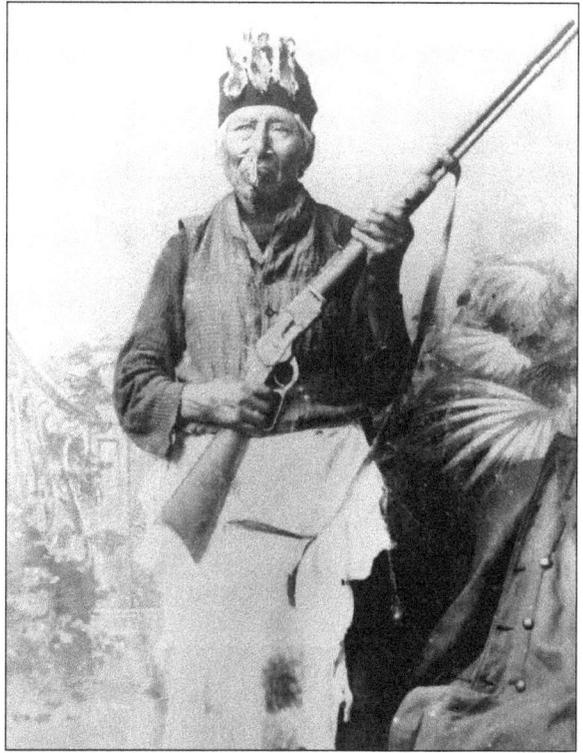

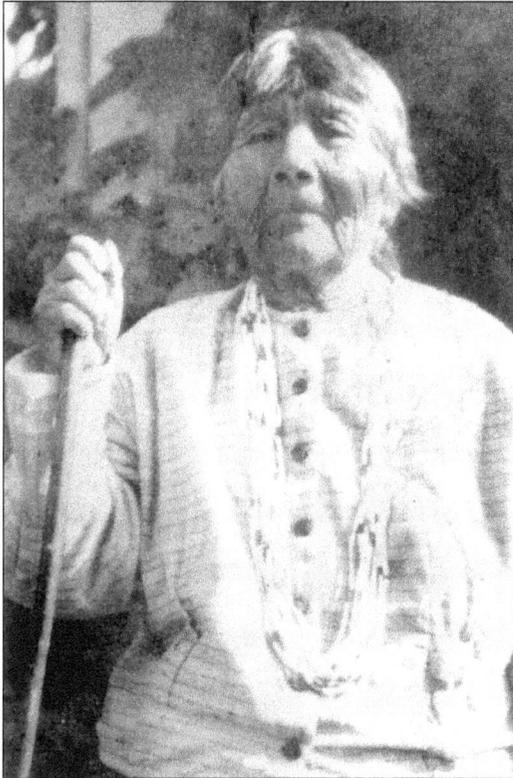

Bessie Snelling was born near Hornbrook, California. She was one of 100 surviving Shasta Indians marched from Fort Jones to the Grande Ronde Reservation in Oregon. If a mother couldn't carry her children, soldiers would smash the child's head on a rock and whip the mother on. Bessie escaped while crossing the Siskiyou Mountains and returned home. She died December 8, 1928, at 118 years old and is buried in Yreka Cemetery. (Courtesy Siskiyou County Historical Society.)

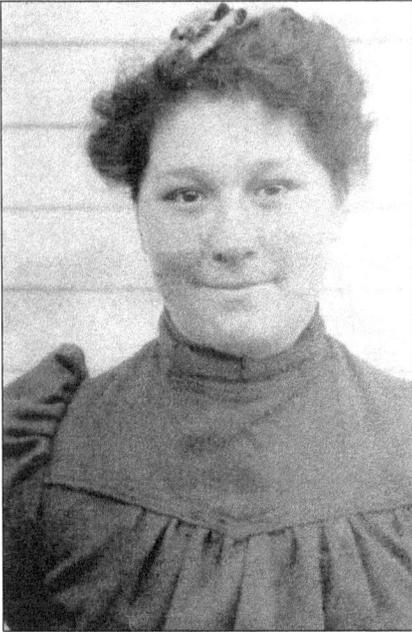

Winnie (Dietrich) Nelson is shown in this photo at the age of 16. Her grandmother was Bessie Snelling. Winnie lived on the Klamath River. She was born June 27, 1884, and died June 18, 1983, at the age of 98. She is buried in the Yreka Cemetery. (Courtesy Betty Hall.)

Jennifer Hall, age 11, and Vera Kopeko, a journalist from Russia, became friends through a cultural exchange program in January 1988. The Russians are quite interested in Native-American culture and the two corresponded until the fall of the soviet Union, when letters from Vera stopped and Jennifer lost contact with her. This photo was taken at the Bernard and Beverly Dowling Ranch in Scott Valley. (Courtesy Monica Hall.)

Like most Shastas, Roy Hall Jr. and his family spend time in the summer months in the Marble Mountain Primitive Wilderness Area. Because of the high elevation, snow covers the ground from November to May, so the camping season runs from May through October. Campbell Lake is one of hundreds of glacial lakes and is easily accessible on horseback or on foot. This trip was special because Roy and his cousin Rodney Eastlick made the trek to Campbell Lake after attending Gene Selby's funeral. Gene was a horseman of the first order and taught Roy much about horsemanship, farrier work, and life. These mountain lakes are full of fish, and a trip to the top of Marble Rim is a breathtaking adventure. Deer, elk, bear, and mountain lion are often seen in the high country. (Courtesy Rod Eastlick.)

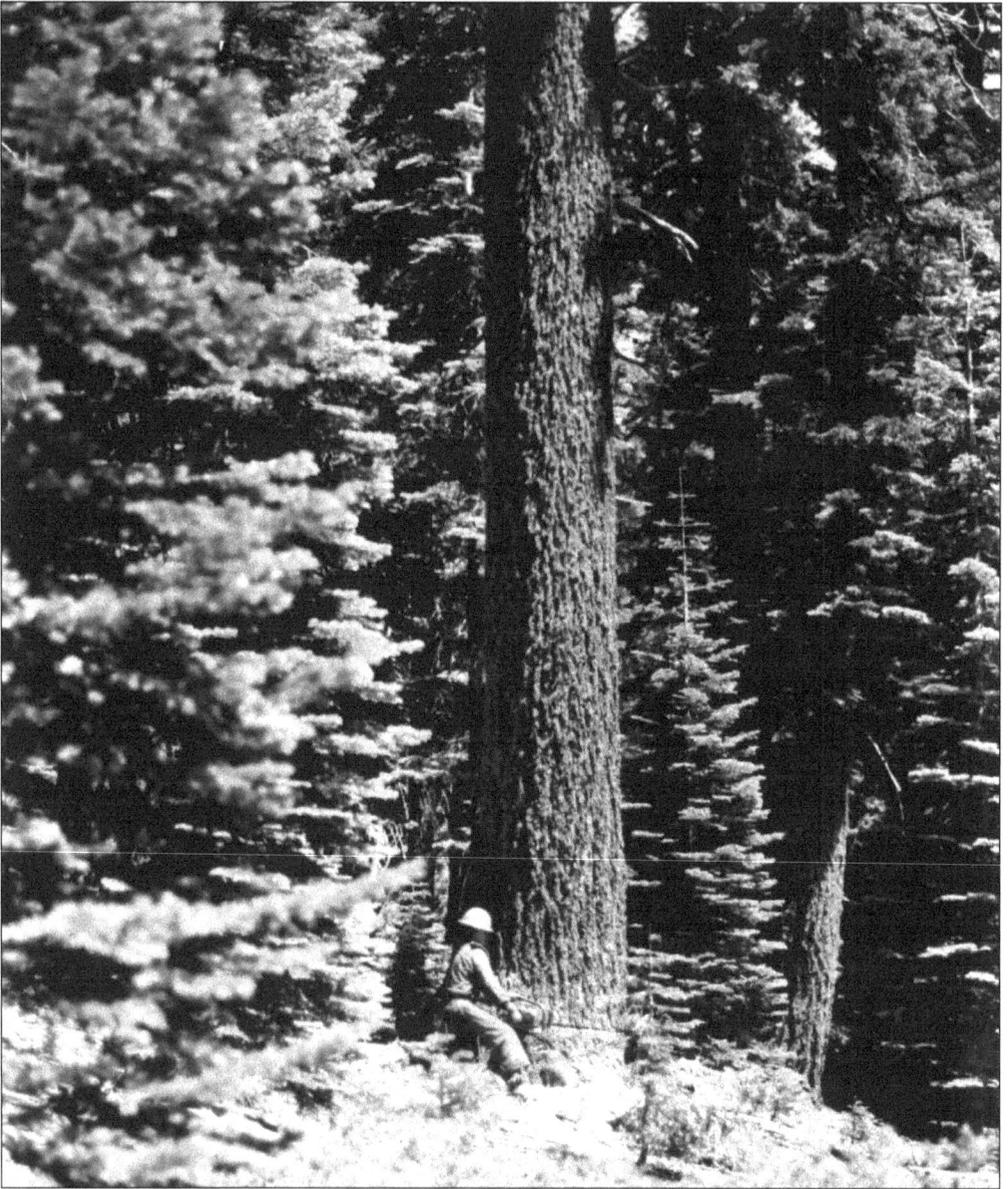

Roy Hall Jr. felled timber for 17 years in California and Oregon. One summer he felled dangerous hazard trees near U.S. Forest Service access roads. This large sugar pine is on Pione Ridge, in Alegheny, California. His father, Roy Hall, grandfather, Fred Wicks, brothers Bill and Glenn, uncle Robert McCallister, and cousin Tom Webster either felled timber or worked in other aspects of logging. Many Shastas own trucks. Logging was the main industry employing Shasta Indians until recently when logging sales were reduced or eliminated. Such restrictions have forced some Shastas to leave the area to find logging jobs in Montana, Idaho, and other areas around the country in order to provide for their families. Most have taken lower-paying jobs just to stay in their homeland, and they now struggle to make ends meet. (Courtesy Monica Hall.)

Sargent Sambo, age 17 at the time of this photograph, was the son of Chief Sambo from Klamath River. After the genocide of the 1850s, his father fled to Oregon and died during the Rogue River War of 1853. Sambo stayed on the Klamath River. He is wearing a good representation of Shasta Indian clothing. Owning many strands of dentalium is a sign of great wealth. The only information we have about his mother is that the garments seen here were buried with her. (Courtesy Virgil Nesbitt.)

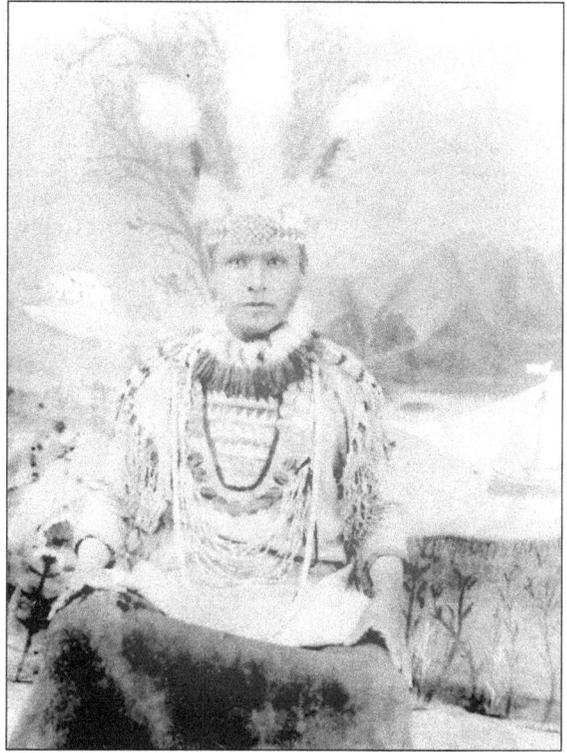

Sargent Sambo is seen here as an elder in this c. 1950 photo. Betty Hall met him a few years before he died in 1963. Shirley Silver, a linguist from Sonoma State University and Berkeley, California, came in the 1960s and worked with Sambo and Betty's great aunt Clara Wicks to record the Shasta language before it was lost. Sargent Sambo was the last full-blood Shasta Indian. (Courtesy Siskiyou County Historical Society.)

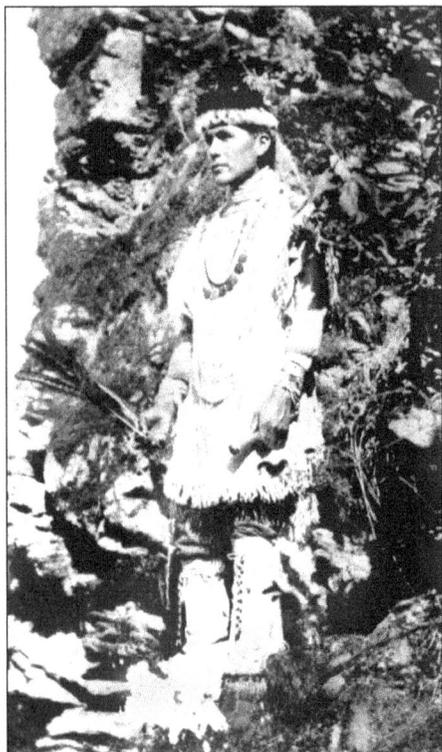

Sargent Sambo is pictured here in his middle years. He gained a reputation as a good cook and traveled with the local ranchers when they drove their cattle to the mountains in the summer months. He cooked for the crews and kept the camp clean. At one time he cooked for the Hornbrook Hotel in Hornbrook, California. (Courtesy Siskiyou County Historical Society.)

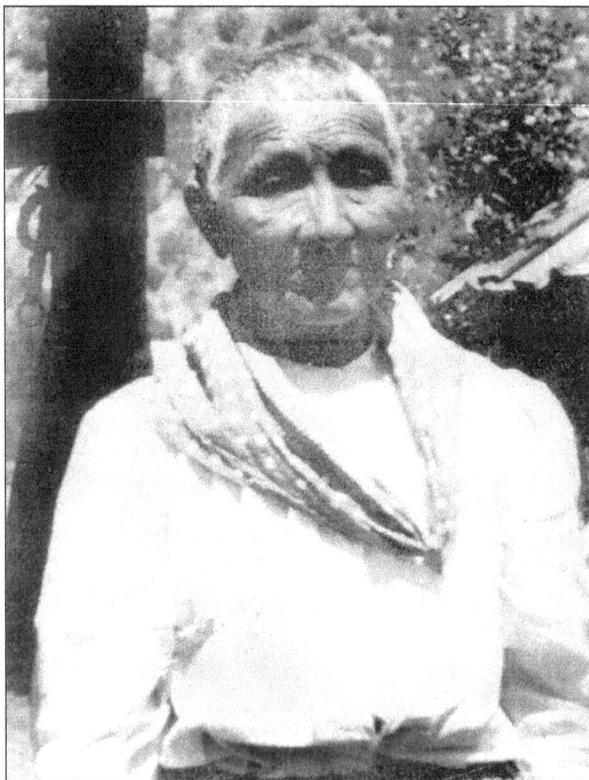

Sarah (John) Doc Duzel, shown here, was Hamburg John's sister, according to Sarah's descendent, Oda (Brown) Hesel, who spoke to Betty Hall. Sarah lived at Hamburg, and of the seven Shasta Indian allotments granted in Hamburg, most went to Sarah's family. (Courtesy Marjorie Brooks.)

Marrion Stafford from Hamburg is shown here wearing her beautiful white buckskin dress decorated with beads. This is one of only a few known photos showing original Shasta garments. When one of our current Shasta elders, Ida Capello, saw this picture she said, "The tree design which appears to be just growing out of the front was a common design on the Shasta garments." This picture was taken at Haskel, an Indian college, in Kansas. (Courtesy Marjorie Brooks.)

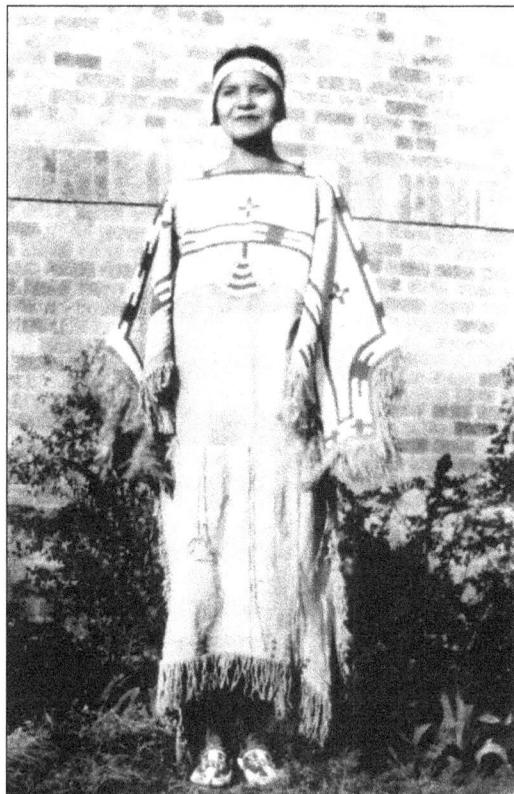

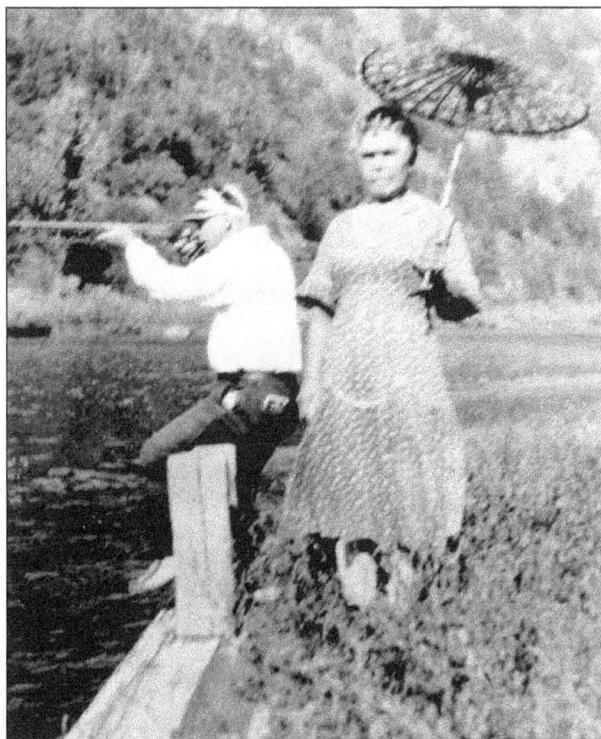

George Martin and Kate (Duzel) Martin are shown on an outing. On Sundays Kate would put on her best dress and, with her parasol in hand, would walk down the main street of Hamburg to go visiting. Kate's daughter-in-law Ida was a lady from San Francisco and she said that the sophisticated ladies of San Francisco had nothing on Kate. (Courtesy Marjorie Brooks.)

Oliver Brown, at left, and Roy Hall Sr., pictured at Hamburg, California. Roy met Oliver at the Hamburg store one day and found out they were related. Oliver's family had an Indian allotment at Hamburg for many years. Oliver descends from Doc John, who was the sister to Roy's great-great grandfather, Hamburg John. (Courtesy Betty Hall.)

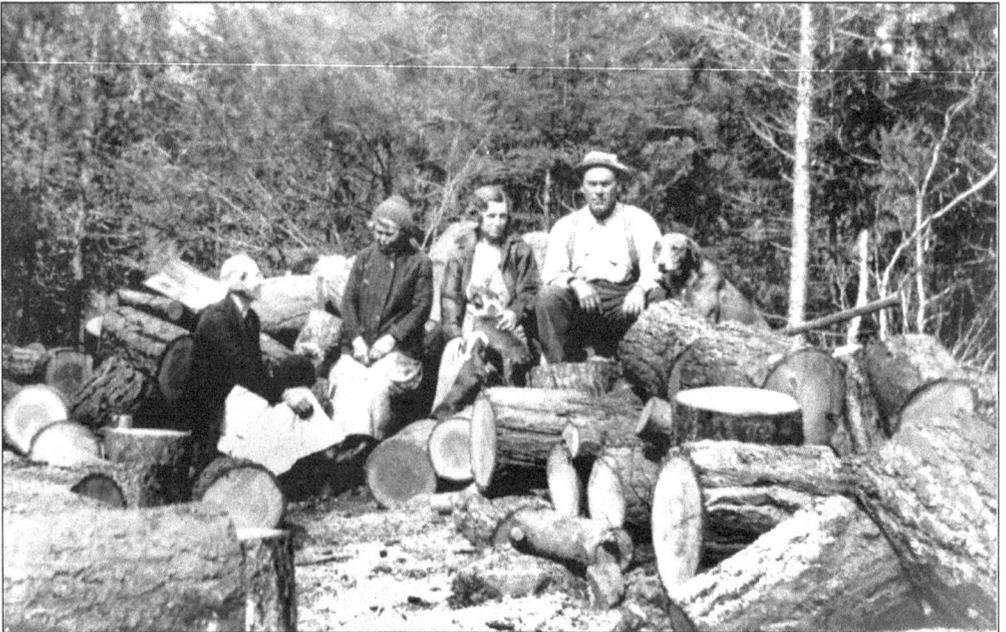

Shown here from left to right are Sarah Doc Duzel, Kate Martin, and two unidentified people. Sarah is out with her family getting in wood for the winter. Sarah was a sister to Mary Ann Bender, Jenny Wicks, and Nina Morgan. Applegate John was her brother. (Courtesy Marjorie Brooks.)

24

Henry Joseph, a full-blood Shasta Indian medicine man, was born at Happy Camp, California, on July 4, 1846, and died May 28, 1932. Once he was visiting Tyee Jim in Quartz Valley at the Wicks ranch, where he doctored Clara Wicks. She said she never had a headache again in her life. Henry Joe had a brother who was taken to the Siletz Indian Reservation, in Oregon. *c.* 1900. (Courtesy Pat Martin.)

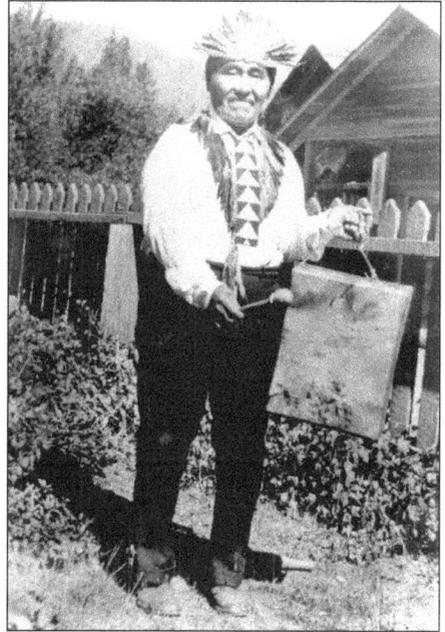

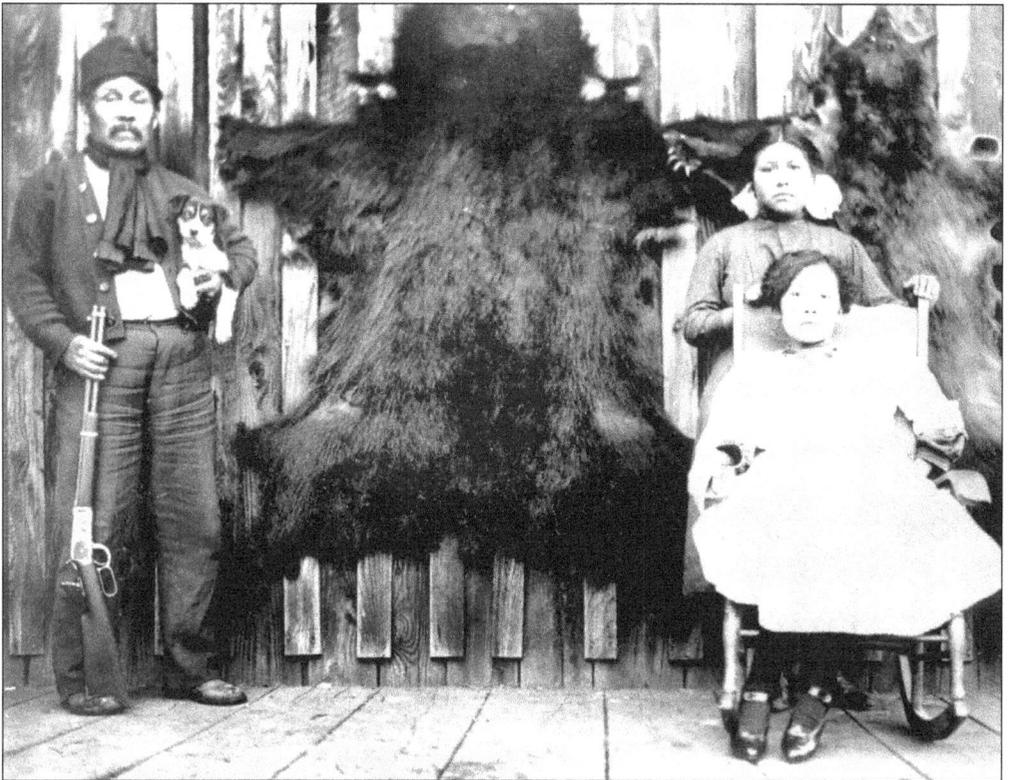

Shown here left to right are Henry Joseph, Jennie Joseph, and Kate Joseph (seated). Chief Joe, as Henry was known, is holding his bear dog, and a large bear hide is hanging on the wall. After contact time, many Shasta men became trappers and sold hides to support their families. Some still trap and tan hides today for their own use. (Courtesy Pat Martin.)

Elmer Lyons, shown here *c*. 1877, was a very attractive little boy. He grew up on the Upper Klamath River at Gottville, California. He remembered playing on the large Rain Rock there. Later the Rain Rock was taken to the Fort Jones Museum and has become a famous landmark, with people as far away as New York requesting that it be covered to prevent rain during big events. (Courtesy Bonnie Bailey.)

Elmer Lyons, shown in the foreground, is at the Shasta Nation Annual Gathering held in Etna City Park, *c*. 1983. Elmer was active in tribal life for many years until his health failed. His memory was sharp and he passed on his wealth of Shasta history to Betty Hall. He was a good friend of Caraway George. (Courtesy Betty Hall.)

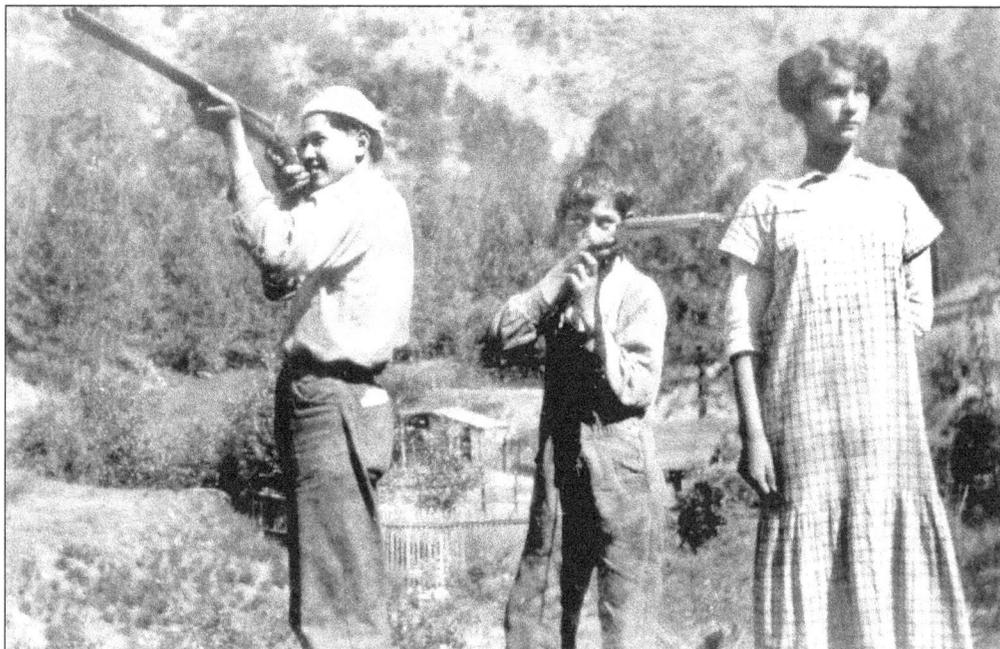

From left to right are Elmer Lyons, Walter Hastings, and Clara Hastings, spending the day outside. Elmer is taking aim with his double-barreled shotgun. The authors don't know what Walter is doing, but Clara is interested in Walter's target. Elmer made his home in Hornbrook, California, for many years after he retired from the army. (Courtesy Bonnie Bailey,)

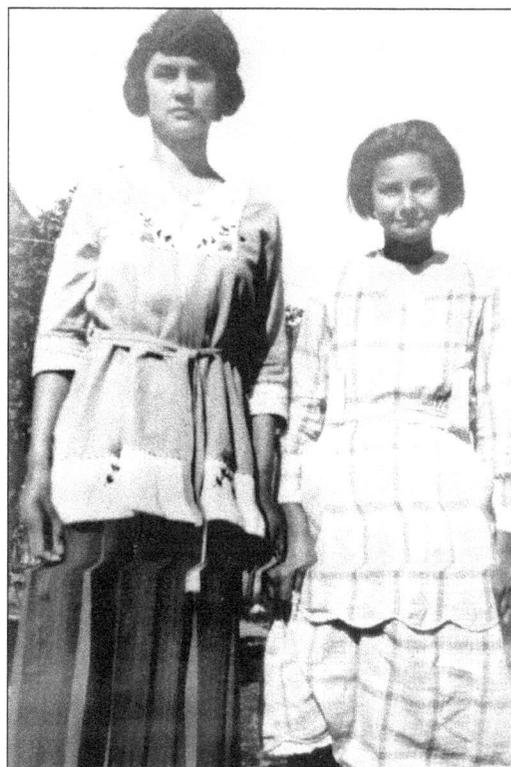

Shown here are Clara (Hastings) McNames, at left, and Myrtle Wilson. Clara married the uncle of Jess McNames and moved away. Myrtle still lives in Siskiyou County. (Courtesy Bonnie Bailey.)

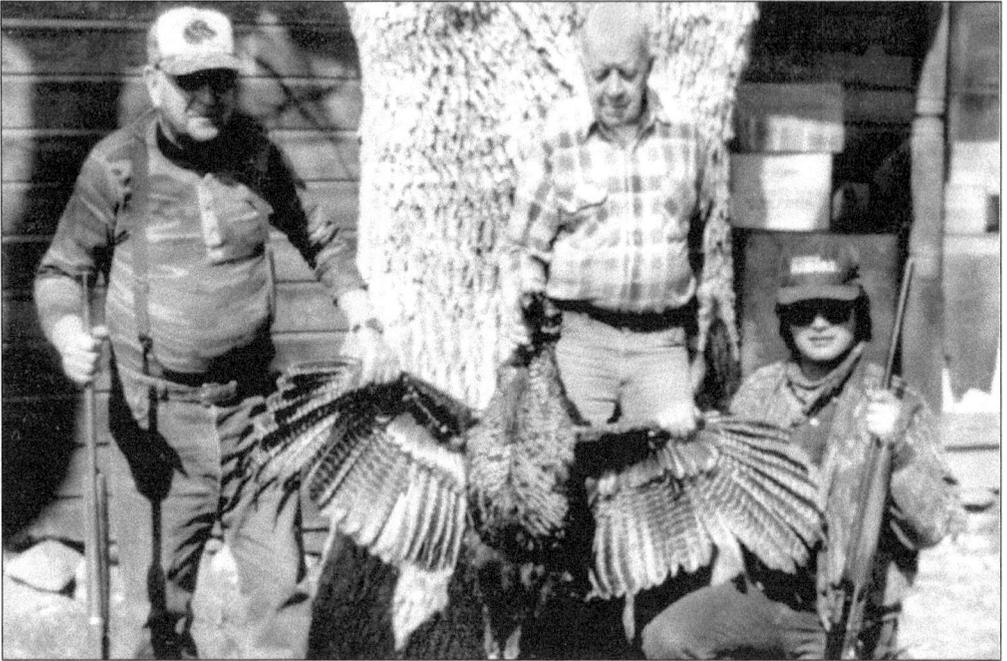

Shown here *c.* 1992, from left to right, are Jess McNames, Orel Lewis, and Roy Hall Jr. with a wild turkey. Jess and Roy bagged the bird on the east side of Scott Valley on their very first turkey hunt. Jess was so excited to show off his trophy to his good friend Orel Lewis that he broke his usual speed limit of 40 mph and actually drove 55 mph to Orel's house in Oro Fino. (Courtesy Monica Hall.)

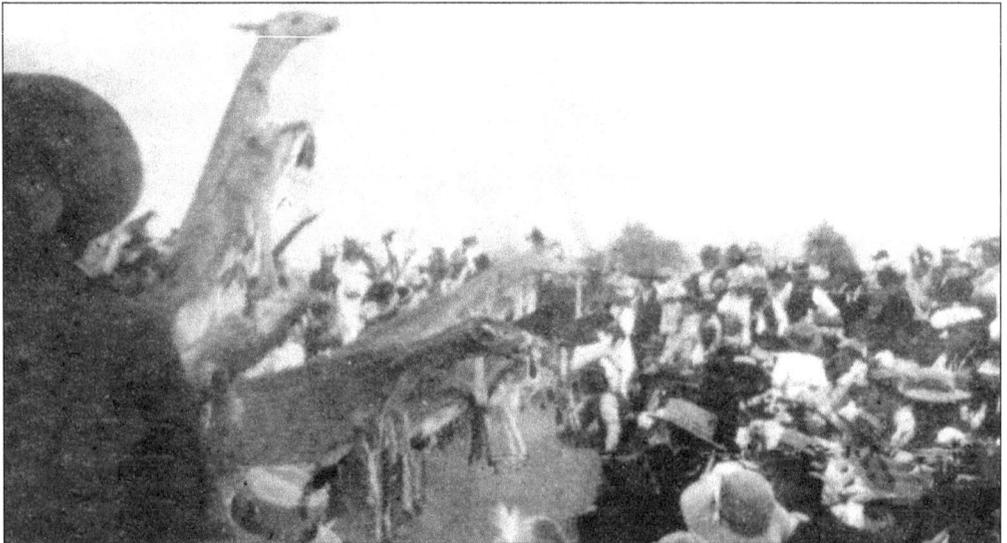

This White Deerskin Dance was performed around 1890 on the Upper Klamath River, at Camp Creek, in the area that is now under Iron Gate Reservoir. White deer are quite rare and owning a decorated skin is a privilege. These hides are passed down through the generations. These white deerskins were elaborately decorated with pileated woodpecker scalps (a large black-and-white woodpecker with a red crest). Someone in front is wearing an Indian basket hat. (Courtesy Betty Hall.)

Chief Ida-kar-i-wak-a-ha (Ike), seen here *c.* 1873, was one of the 13 Shasta Chiefs who signed a treaty in Scott Valley, California, on November 4, 1851. Ike escaped the genocide (see Introduction). He controlled Upper Klamath River, Butte Valley, and North Shasta Valley. Chiefs Joe and Sam in Rogue River were his brothers. Chief Ike was captured with Captain Jack and was sentenced to Alcatraz for life. (Photo by L. Heller, courtesy Caraway George.)

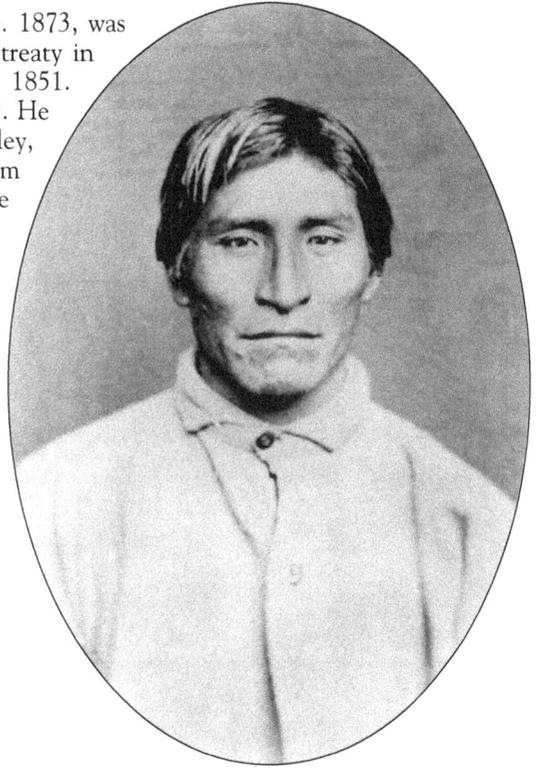

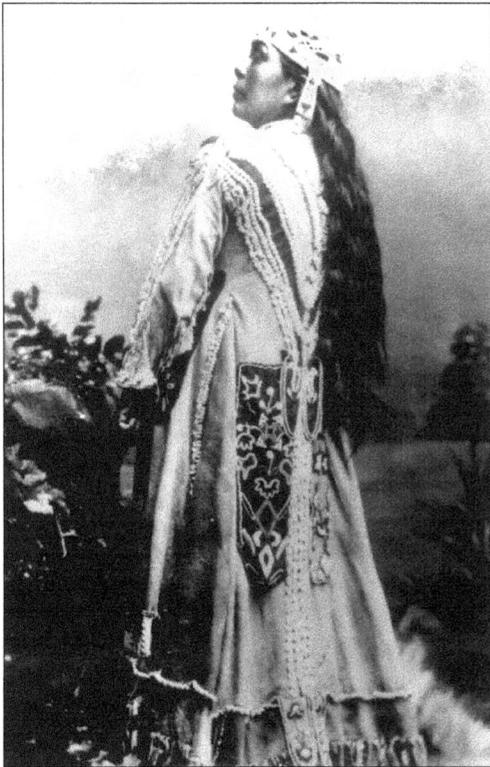

This is Jennie George of Jacksonville, Oregon, also known as Lady Oscharwasha. She was born about 1850. Her father was Andrew George, a Catawba Indian from North Carolina, and her mother was a Rogue River Shasta Indian. Jennie made this beautiful robe in which she was laid to rest in May 1893. She was a half-sister to Caraway George's grandfather, James Daniel George. (Courtesy Caraway George.)

Shown here is James Daniel George, son of Andrew George and Polly Ike. Andrew and Polly died; Andrew from Civil War wounds. Chief Ike walked and Mary rode a horse to Jefferson Barracks, Missouri, to get their orphaned grandchildren James, Jennie, and Missouri Ann. Ike also returned with the remains of 28 Shasta Indian Civil War veterans. They were given a full military burial on the Upper Klamath River. (Courtesy Caraway George.)

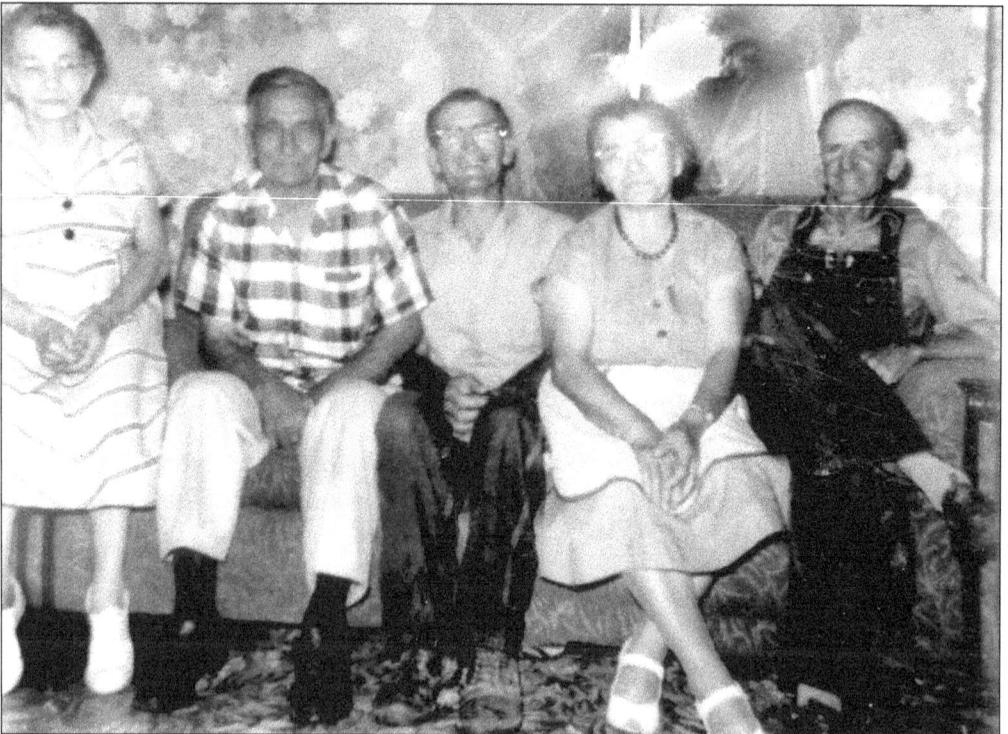

Shown here from left to right are Bessie George, William Henry George, Harrison Skidmore, Pearl (George) Skidmore, and Milo Skidmore. William is the father of Caraway George; Bessie and Pearl are his aunts. Milo is a cousin to Caraway. William lived in both California and Missouri. Their mother is Rhoda Bess from Missouri. The Georges descend from Chief Ike. (Courtesy Caraway George.)

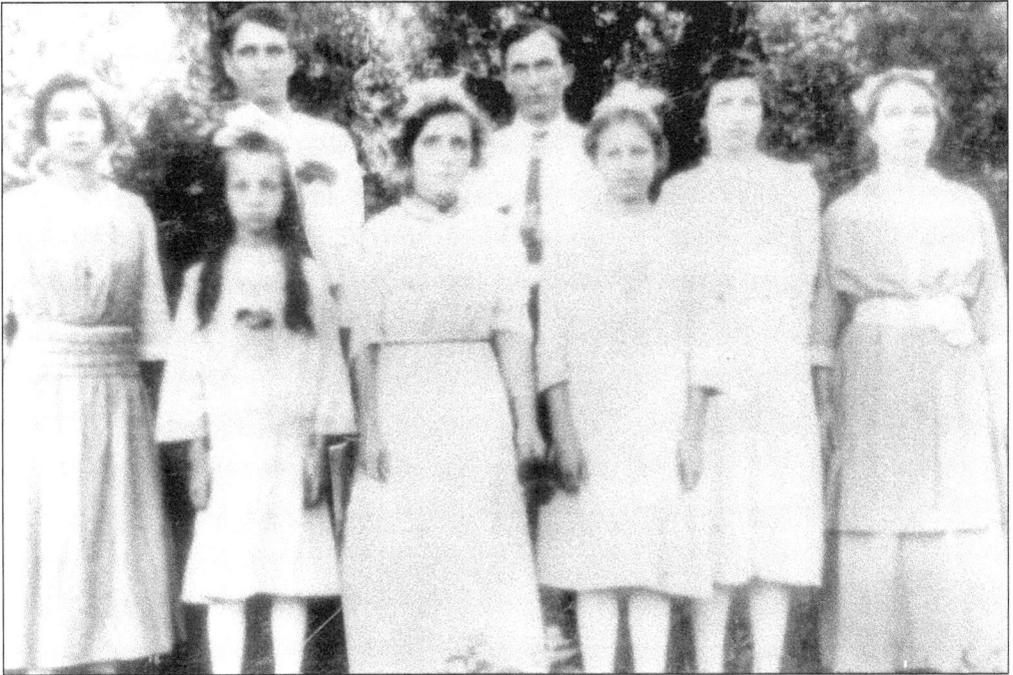

These are the children of James Daniel George and Rhoda Jane Bess when they were young. The men in the back are from left to right, William Henry George and Joseph Harrison George, who died in France in WWI. The girls are their sisters. (Courtesy Caraway George.)

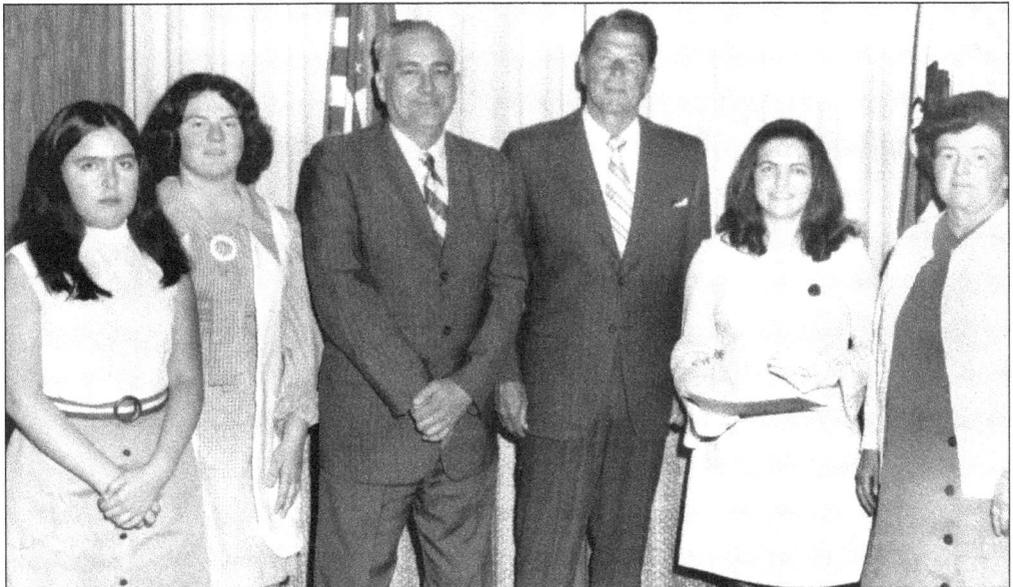

Pictured here from left to right are Patricia, Fay, and Caraway George; Governor Ronald Reagan; and Nancy and Louise George at the state capitol in Sacramento, California, in the 1970s. Nancy received a citation from the governor for designing a teaching plan at Yreka High School that is still being used today. Nancy received a large medal, which throughout her life would give her access to Ronald Reagan. Nancy was in high school at the time. (Courtesy Caraway George.)

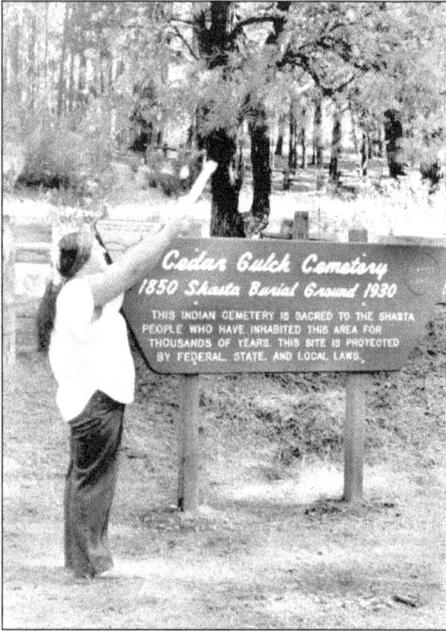

Nancy (George) Vanderploeg is dedicating the New Cedar Gulch Cemetery sign made by Simpson Lumber Company and the U.S. Bureau of Land Management. This burial ground had been dug up, and there were holes big enough for a car to fit in. Nancy, Betty, and others gathered up sacks full of human bones to re-inter. A teacher from Trinity County was prosecuted for grave robbing. Nancy was the first chairwoman of Shasta Tribe, Inc. in the 1980s. (Courtesy Betty Hall.)

Caraway George is seen here pouring water out of his boot c. 1983. He had taken Betty and her family on a tour up the Klamath River Canyon to show them some village sites. Caraway had crawled out on a large limb above the river to show Betty a fish weir. He fell in up to his arms. Betty was more cautious. (Courtesy Betty Hall.)

Caraway George is seen here in the foreground at a Shasta Annual Gathering in the Etna City Park. Caraway had done considerable research. The Shasta people would like to express how grateful they are for all the time and effort he has donated over the years. Caraway helped write and file the Shasta's petition for federal recognition. Caraway George is Betty's mentor and friend. (Courtesy Betty Hall.)

Caraway George and Louise George are at Betty Hall's home after the funeral of her father, Fred Lee Wicks, in the spring of 1987. Caraway told Betty's son, Roy Hall Jr., "I'll be your grandpa now," and he meant it. He helped Roy learn about the government recognition process, and when Roy became chairman of the Shasta Nation at age 27, Caraway gave him advice and guidance. (Courtesy Betty Hall.)

Caraway George, Linda Navarro, and Eric Carpelan are seen here observing village sites and Shasta Indian gathering areas on the Upper Klamath River c. 1982. Caraway is a descendant of Chief Ike, who signed the treaty with the Shasta at Upper-Klamath in Fort Jones November 4, 1851. His territory was the Upper-Klamath and part of Butte Valley. (Courtesy Mary Carpelan.)

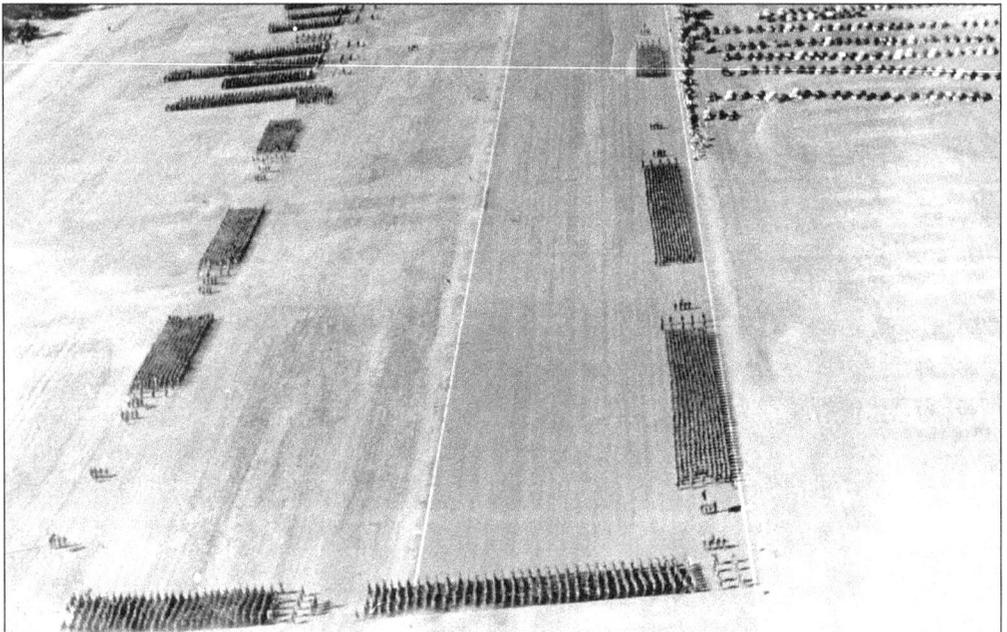

In 1947 at Fort Lewis in Washington State, 50,000 troops passed in review. In the reviewing stand were President Harry Truman, General Dwight D. Eisenhour, and General Mark Clark. Caraway George is somewhere among the 50,000 troops marching past the reviewing stand. Someone did an incredible flyover to get this shot. (Courtesy *Fort Lewis Sentinel*.)

34

Hila and her son Joe Houck are pictured here in Illinois Valley, Oregon. David Houck had a land claim in the Illinois Valley in 1852. When his wife died he went to Happy Camp and bought Hila from Chief Ida-kar-i-wak-a-ha (Big Ike). David and Hila had 11 children. When David died, Hila was forced off his land claim. Hila was born December 31, 1845, and died March 12, 1920. (Courtesy Jim Prevatt.)

Shown here from left to right are Bertha, Robert, and Marge Prevatt at home in Kerby, Oregon, c. 1950. Bertha is one of the daughters of Hila and David Houck. Bertha worked hard to provide for her five children, despite the polio that kept her in a wheel chair. (Courtesy Jim Prevatt.)

Darlene, Nancy, Barbara, and Jim Prevatt, pictured here from left to right in the late 1940s, look like real kids. Bertha Prevatt, their mother, wrote on the back of the picture, "A Bunch of Beggers. It would never have been so good if they were cleaned up." The family was never at a loss for entertainment and took life as it came. (Courtesy Jim Prevatt.)

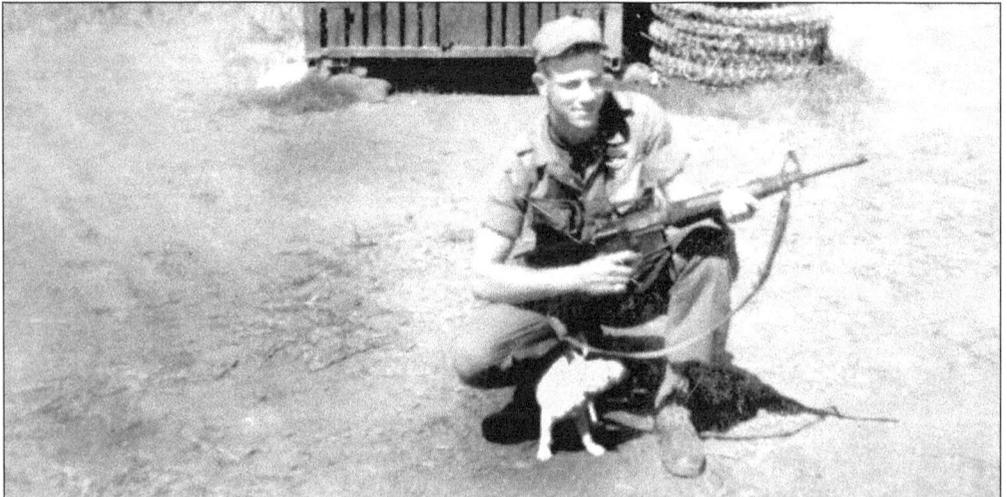

SFC James "Skywatcher" Prevatt served in the United States Army from 1959 to 1970, with over five years in Vietnam in the central highlands. He was a helicopter door gunner from 1964 to 1965. He was an instructor at LLRP School near Pleiku, and an RTO (combat radio operator) with MAC (Mobility Airlift Command) V Sog. He came home in 1970. The photo was taken at an 11 Corps special forces camp near Ia Drang, Vietnam, in 1966. (Courtesy Jim Prevatt.)

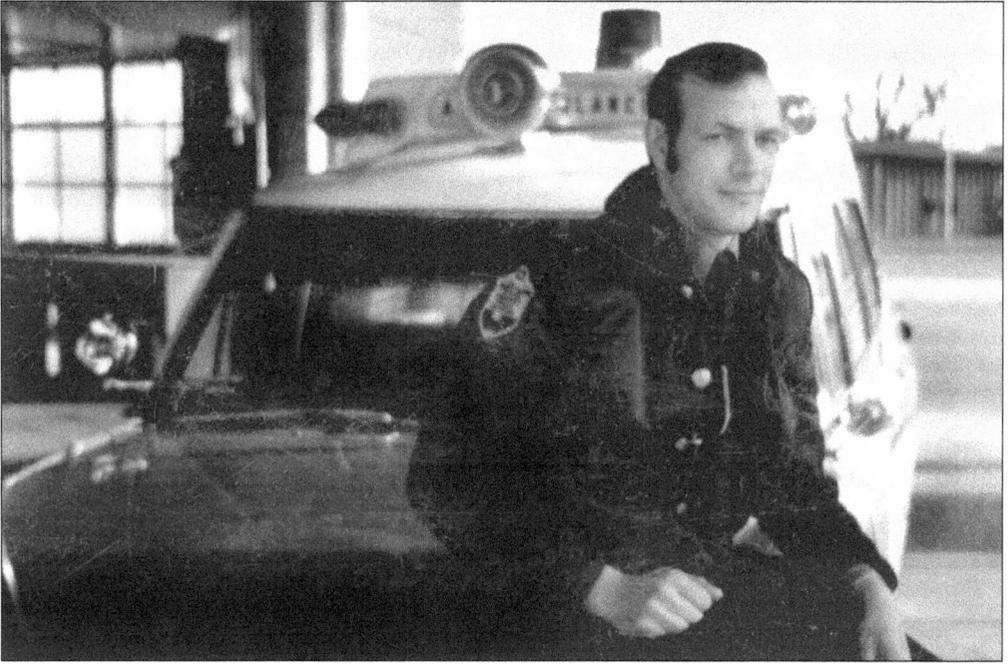

Jim Prevatt is standing next to the ambulance he drove when he worked in Portland, Oregon, after leaving the military. His medical status was emergency medical technician-4, and physician's assistant. He retired due to ill health in 1980. This photo was taken between 1970 and 1980. He has a foster daughter Cassie and lives in Medford, Oregon. (Courtesy Jim Prevatt.)

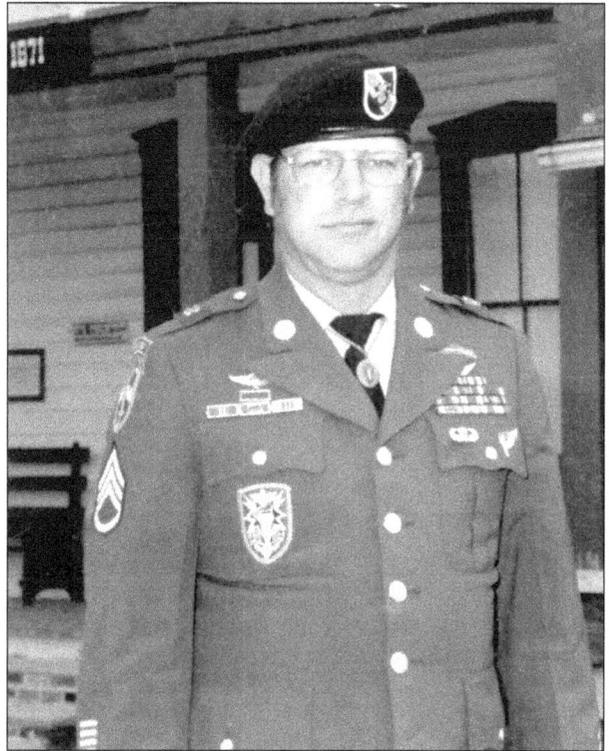

This picture was taken in Kerby, Oregon, in 1987. Some of SFC Prevatt's medals include DSC 1969, Silver Star 1964, Bronze Star with V Device 1964, four Purple Hearts between 1964 and 1970, and CIB. (Courtesy Jim Prevatt.)

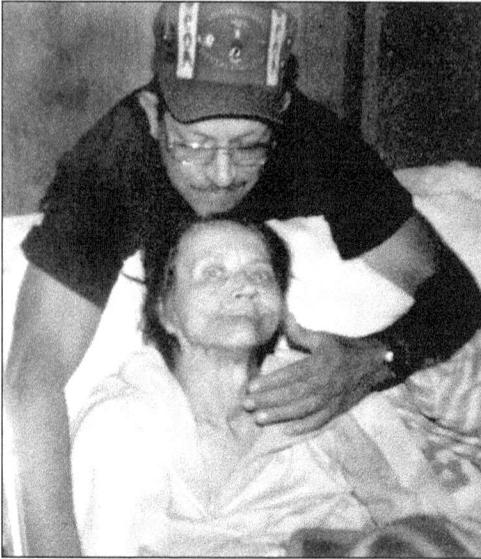

Bertha Prevatt and her son Jim Prevatt are shown here in the hospital. This picture was taken September 22, 1989. Bertha died the next day. Jim was very close to his mother, and he speaks of her fondly and with deep respect. Often he tells humorous stories of her ingenuity in raising five wild children from a wheel chair. (Courtesy Jim Prevatt.)

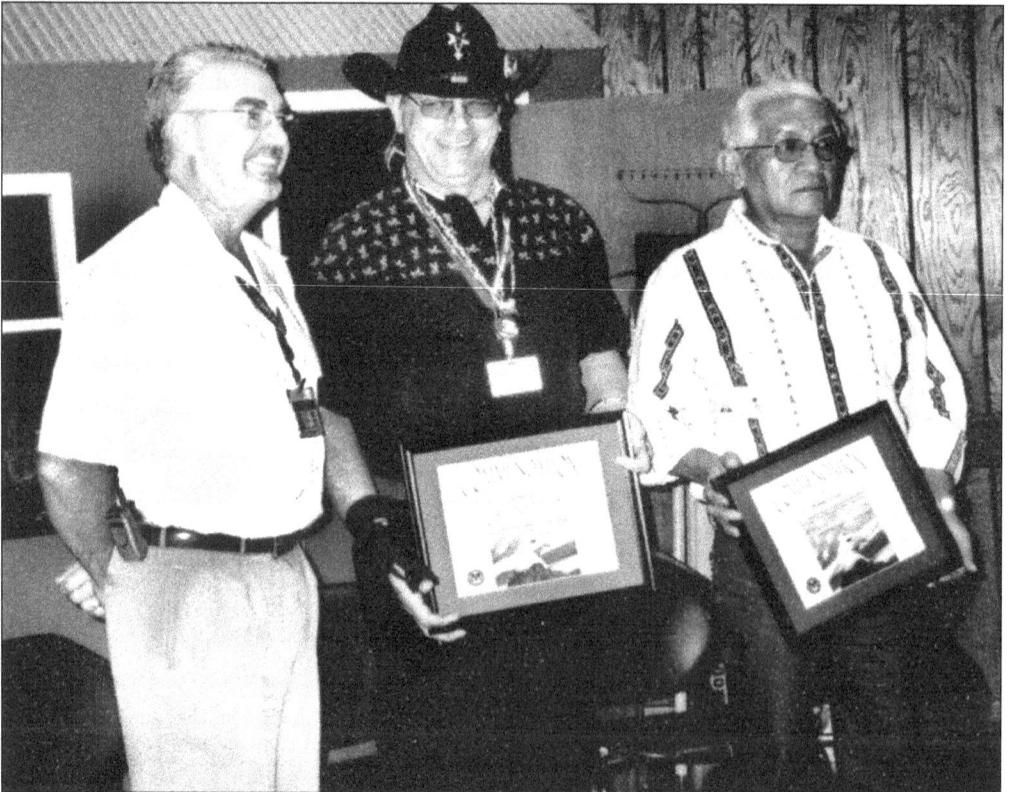

Shown here from left to right in spring of 2004 are Scott Walker, chief of the Medical Administration Service of the Veterans Association; Jim Prevatt, Shasta Indian; and Richard Ochoa, Klamath/Yaki Indian. Jim and Richard were honored for their efforts to make it possible for Indian veterans to have sweat lodge ceremonies and an annual pow-wow at the Veterans Domiciliary in White City, Oregon. Jim was also awarded a Warrior's Medal of Valor from the Native Nations of America. (Courtesy Betty Hall.)

Jim Prevatt, Venice Hidalgo, and Eric Carpelan are pictured here from left to right in December 2002. They are attending an elders' supper at the Southern Oregon Indian Council, in Grants Pass, Oregon. Venice, three years old, had not seen Jim for months, but when she saw him she said, "There's my man." and ran to him, arms up. She was quite content to spend the evening with him. Jim was so touched he could hardly handle it. (Courtesy Betty Hall.)

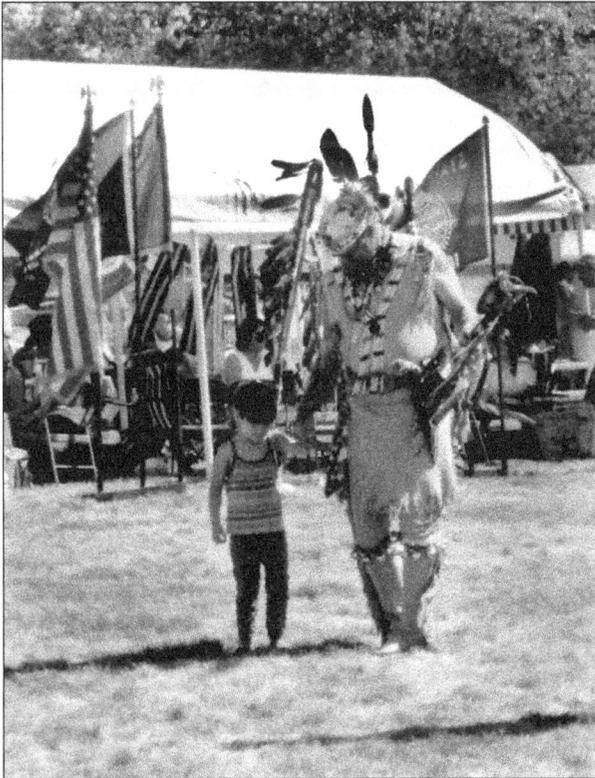

Venice Hidalgo, age four, and Jim Prevatt, dance at a veterans' pow-wow at the Veterans Domiciliary in White City, Oregon, in 2003. Venice sat quietly all day with her aunt Mary Carpelan watching the dancers. Finally Jim came over and asked if she was ready to dance. She said yes and took his hand. (Courtesy Mary Carpelan.)

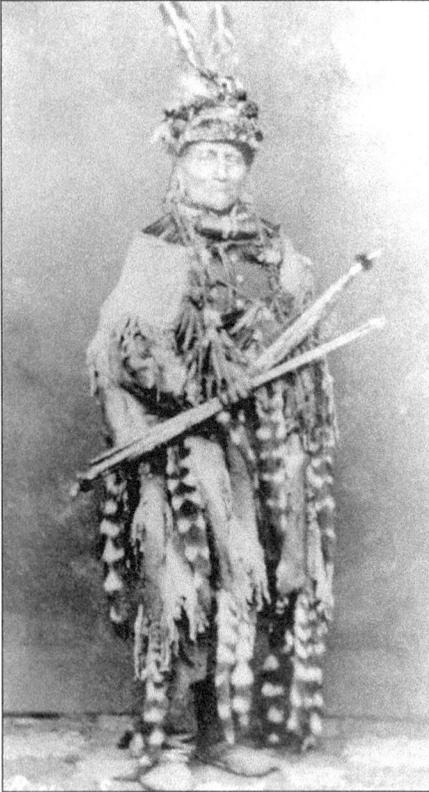

Chief SunRise, Got-a-uke- Ek-su, was born on Kelsey Creek. He signed the Treaty at Fort Jones in 1851 (see Introduction). A barbecue was prepared. Poison was put in the beef and bread. Thousands of Shastas died. Chief SunRise and Tyee Jim did not eat. Vigilantes burned every village. It is written that about 170 warriors fled to the mountains. SunRise lived in the mountains for two years. (Courtesy Don Boat.)

Betsy (Johns) Frain was the daughter of Chief SunRise, and she was born where Mugginsville is now located in Quartz Valley, and later married Martin Frain. Their first child was born at Indian Creek in Scott Valley. The family moved to the Upper Klamath River, where their other children were born: Frank Frain, Frederick (Fred) Frain, Lorenzo Frain (Wren), Roderick Frain, (Rod), Nettie (Frain) Way, and Alfonzo (Al) Frain. (Courtesy Don Boat.)

Betsy and Martin Frain pose here near some ivy. Martin Frain was a trader between Yreka and Klamath Falls. He spent very little time with his family at their home on the Klamath River. Instead he chose to live most of the time in Klamath Falls, alone, and would stop to visit on his trade route through the canyon. (Courtesy Don Boat.)

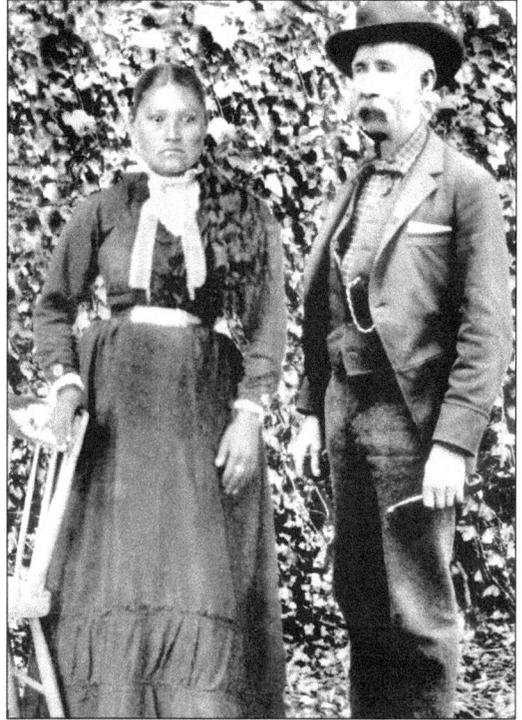

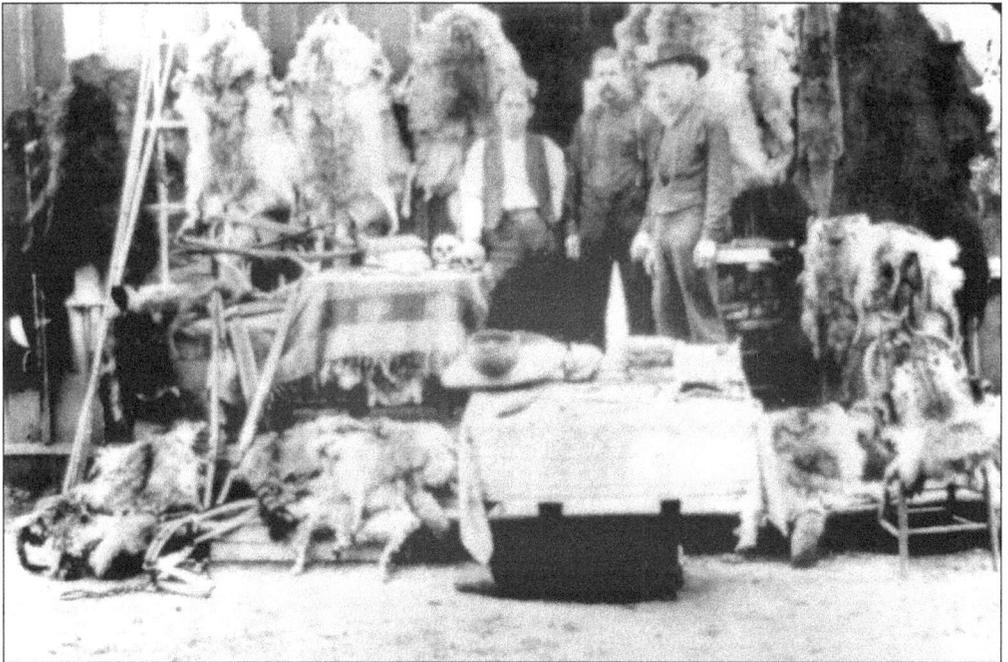

Pictured from left to right, are Al Frain, unidentified, and Martin Frain with a display of some of his furs and artifacts. The picture was taken at the "Cave House." It was located across the Klamath River from a large cave shelter that the Shasta Indians had used (see page 14). This is where most of the artifacts, including the two skulls on the table, came from. (Courtesy Don Boat.)

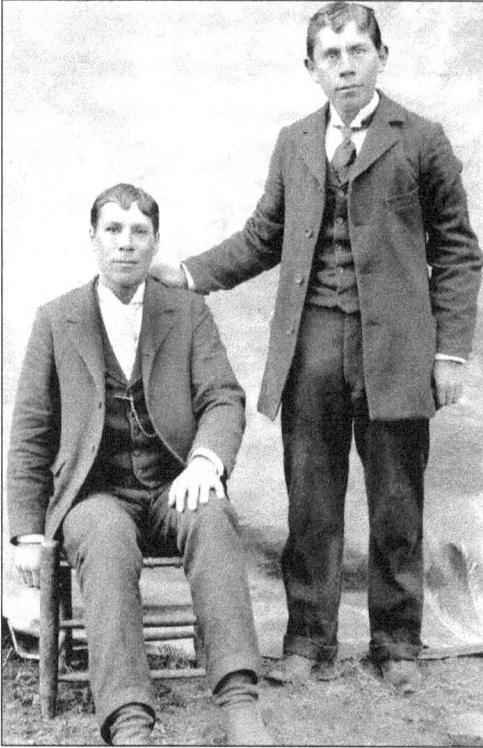

Shown here are Roderick Martin Frain, seated, and Alfonzo Frain on March 7, 1898. (Courtesy Don Boat.)

Wren Frain, Frank Wood, Al Frain, and Rod Frain, shown from left to right, pause in front of the Salt Cave, on Klamath River. This picture was taken in 1897. The City of Klamath Falls in Oregon proposed that a dam be built here in the 1980s. The dam would have covered extremely sensitive cultural areas of the Shasta Indians. (Courtesy Don Boat.)

42

Loren Close, left, and Fred Frain are seen here after a long day's hunt. This buck is typical of the black tail deer that still range through the steep bluffs of the Klamath Canyon. People still walk these mountains each fall searching for the elusive bucks. Finding and getting close enough to get a shot takes time, patience, and a bit of luck. (Courtesy Don Boat.)

Shown in this photo, left to right, are unidentified, Vera (Frain) Hutchins, William Frain, and Effie Frain. Shortly after this picture was taken William and Effie sold the property and moved to Ashland, Oregon. (Courtesy Don Boat.)

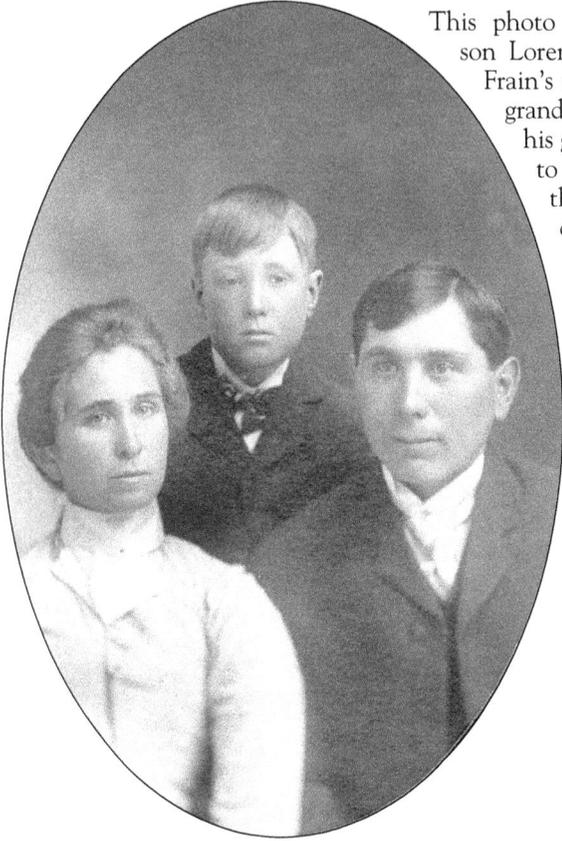

This photo shows, from left to right, Ida Frain, son Loren Close, and Fred Frain. Loren is Fred Frain's son and the father of Grace Bailey, and grandfather of Donald Boat. Don remembers his great grandfather took him to some caves to meet with other Shasta Indians when they were supposed to be out fishing for dinner. Don was too young to remember where they went or who was there, but he remembers they spoke the Shasta language. (Courtesy Don Boat.)

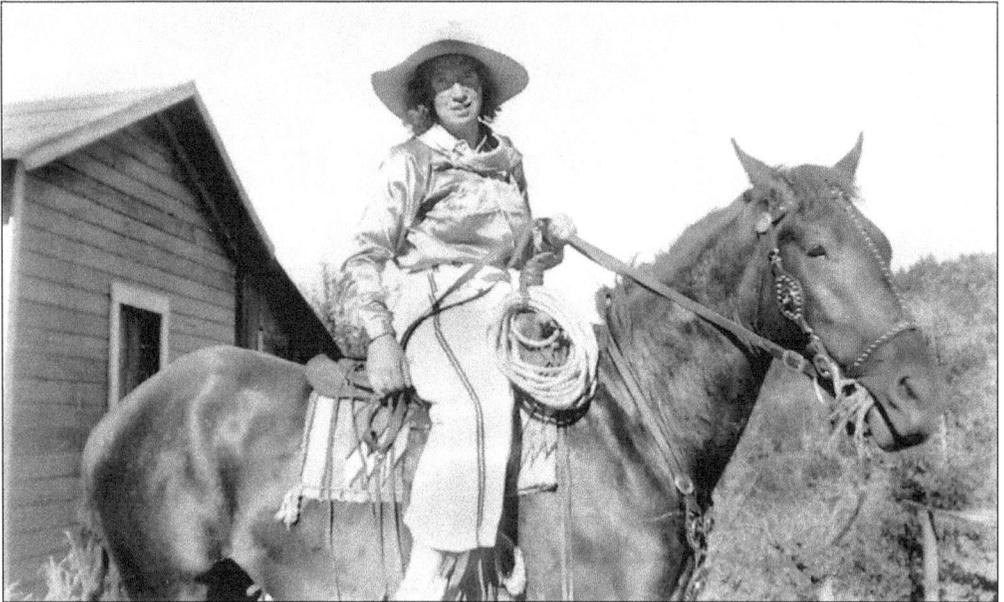

Grace (Close) Boat rides a horse on 42 Scenic Drive in Ashland, Oregon, c. 1947. She was raised in town but rode often. Grace raised her children here for several years. (Courtesy Don Boat.)

Grace (Close) Boat, and her husband, Roy Boat, stand smiling shortly after they were married. Grace is the daughter of Loren Close. This picture was taken at Camp Roberts, near Paso Robles, California. They had five children: Ronald, Donald, Joan, Lona, and Lawerence. (Courtesy Don Boat.)

Grace (Close) Bailey and Edwin Bailey traveled from Cottage Grove, Oregon, to attend Roy Hall Sr.'s birthday party in Greenview, California, in March 2003. Roy was 70 years old. His children, grandchildren, and great grandchildren were in attendance along with other family and friends from the community. (Courtesy Betty Hall.)

Donald Boat and Mary Carpelan visit here during the Annual Shasta Gathering at Indian Scotty Campground on the Scott River c. 2003. It is a special time of socializing, basket making, flint knapping, cooking acorns, eating, and telling old family stories around the campfire. People bring their skills and crafts to share. Roy Hall Sr. conducts tours of local villages and sacred areas. (Courtesy Betty Hall.)

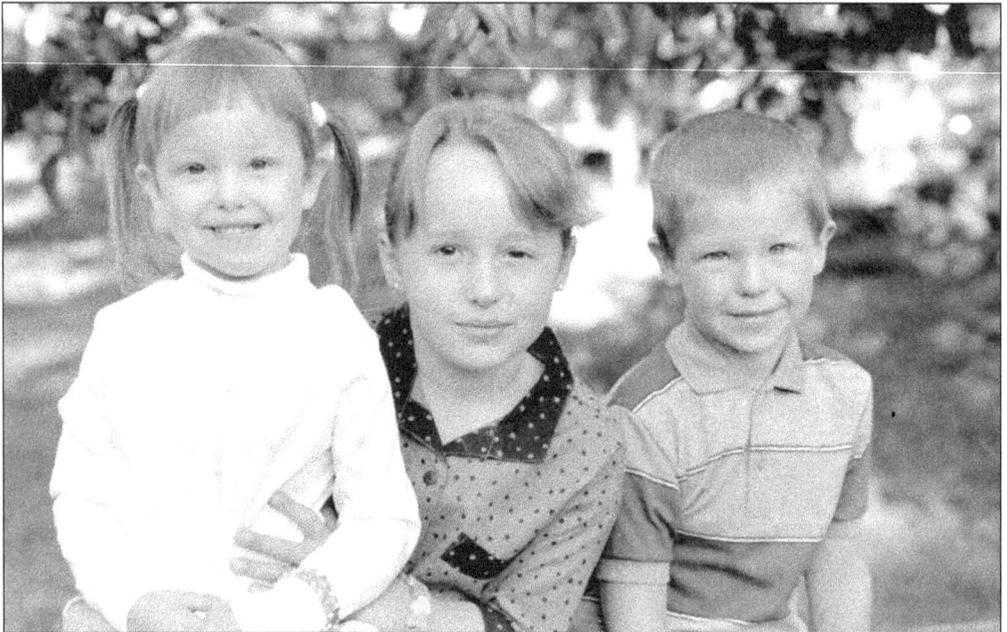

Shown here from left to right are Rayna, Jamie, and Roy Boat, the children of Donald Boat, and grandchildren of Grace Bailey. Rayna is interested in making traditional baskets and ceremonial costumes. Roy would like to build a traditional Shasta house and become a drummer. (Courtesy Don Boat.)

Fred and Ida Frain are shown here in their later years. They spent most of their lives at their ranch on the Upper Klamath River, and then later moved to Ashland. (Courtesy Don Boat.)

Fred and Ida Frain are seen here with their catch of trout. Trout, salmon, and steelhead were dried or canned for use in the winter months. Roots and berries were also gathered and stored along with a substantial harvest from their garden. (Courtesy Don Boat.)

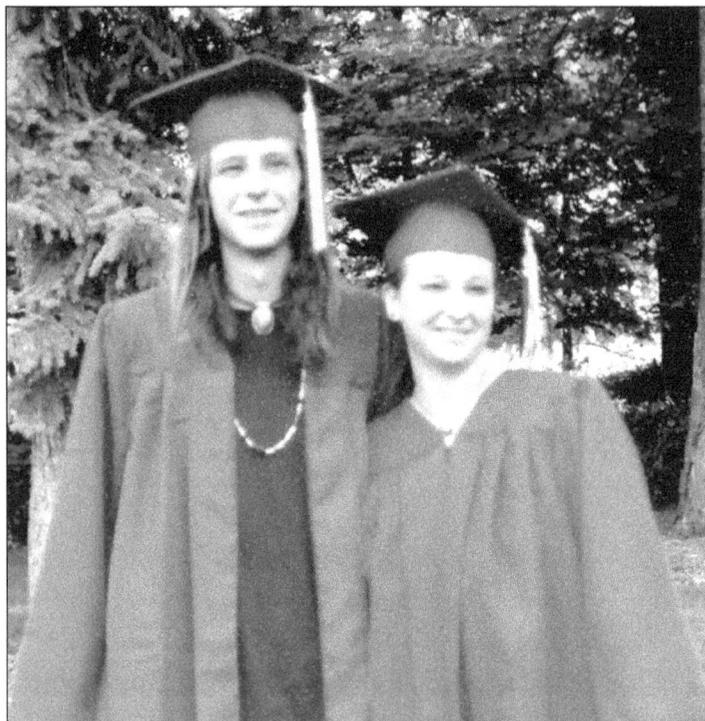

Roy Boat and his sister Rayna Boat are shown here in June 2004, just after their graduation from high school. This picture was taken in Lithia Park in Ashland, Oregon. They are the children of Don Boat, and both are interested in their culture and are involved in learning Shasta crafts such as flint knapping and basket making. (Courtesy Don Boat.)

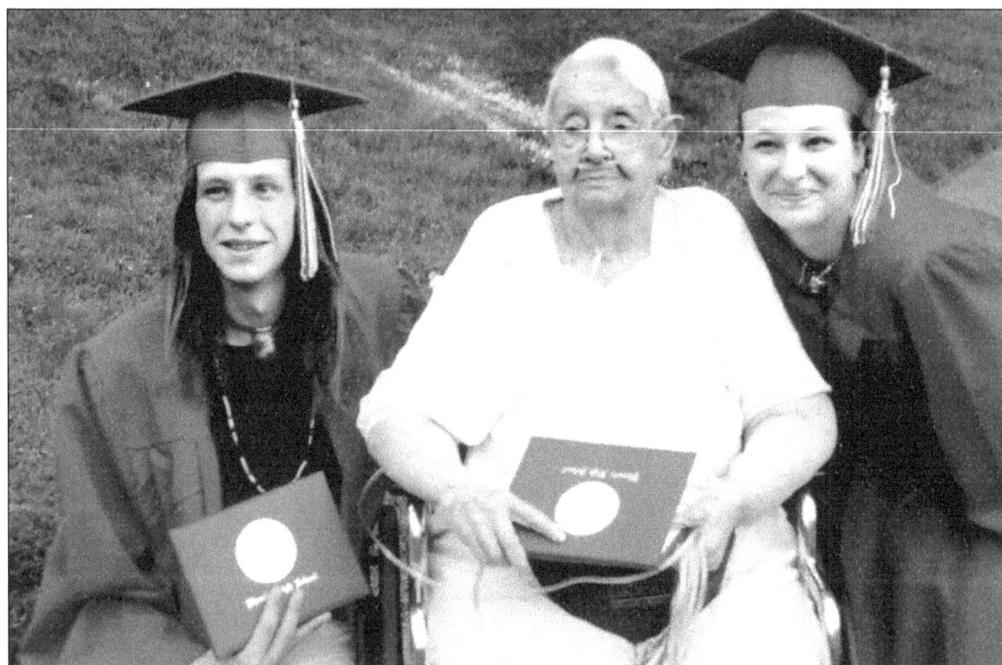

Pictured here from left to right are Roy Boat, Grace Bailey, and Rayna Boat, in Lithia Park. They spend time at pow-wows and tribal gatherings and enjoy passing on family stories. She was a board member of the Shasta Nation for several years. When the Vietnam traveling wall was in Grants Pass on June 25, 2004, her son Don Boat received a Warrior's Medal of Valor from the Native Nations of America. (Courtesy Donald Boat.)

48

Gwen Kinkade and Donald Boat are shown here at their wedding. They reside in Grants Pass. Donald served in the military from 1966 to 1976 and was in Vietnam from 1967 to 1968. He is the vice chairman of the Shasta Nation and has worked at Rogue Valley Door as a machinist for 12 years. Gwen has worked at Royal Gardens Health Rehab Center for 13 years. She teaches Certified Nurse Assistant courses and staff development. (Courtesy Don Boat.)

Randy Bell and his daughter Deborah Bridwell have served on the Shasta Tribal Council for several years. Although Randy has worked as a timber feller for many years, he and his wife, Jean, who live in McArthur, California, also like to mine for gold with their son Roy. Debbie and Andrew Bridwell have three children: Jessie, Martin, and Randall. Debbie works at Premier West Bank and Andrew does ranch work. (Courtesy Betty Hall.)

49

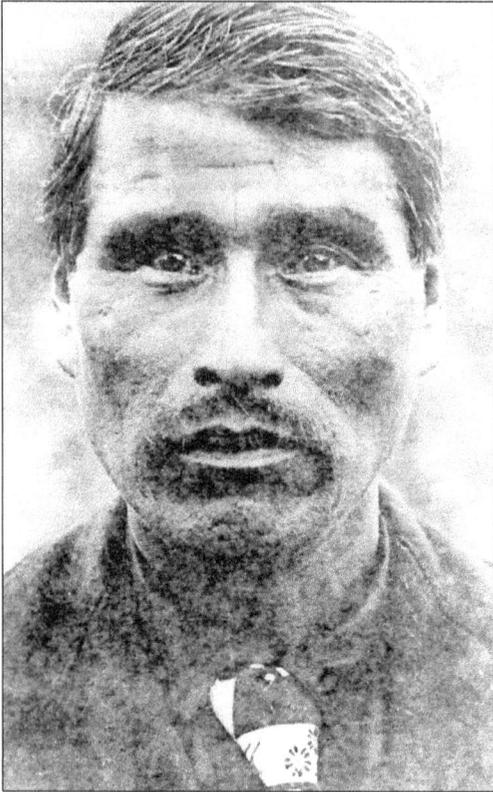

Klamath Billy was the son of Chief Klamath Billy of the Upper Klamath River. When Chief Klamath Billy and his people were being escorted to Fort Jones by unauthorized people in 1852 (see Introduction), they were attacked at Nations Crossing, south of Hornbrook. Chief Klamath Billy and others were killed. The survivors, including the chief's son Klamath Billy, were taken to Grand Ronde or Siletz Reservations in Oregon. (Courtesy Siskiyou County Historical Society.)

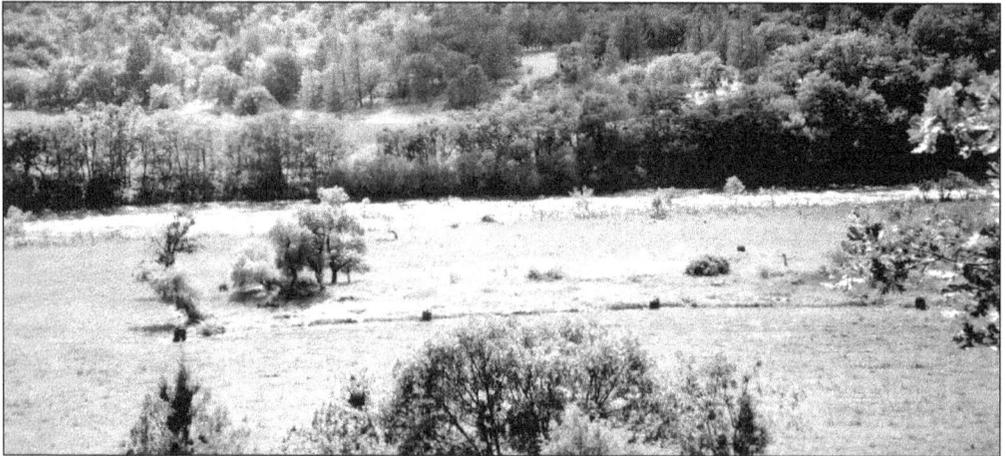

This photo shows the Shasta Indian Civil War veterans' burial ground on the Upper-Klamath River c. 1982. On April 20, 1863, a militia that included Shasta Indians, under Col. Edwin Smart, had about 30 men killed. The Shasta soldiers fell near Patterson, Missouri. Andrew George was wounded there and his father-in-law, Chief Ike, went after his orphaned grandchildren. Ike also returned the 28 fallen Shasta soldiers' remains and buried them on the Klamath River with full military honors. (Courtesy Betty Hall.)

50

Two

SCOTT, SHASTA, AND QUARTZ VALLEYS

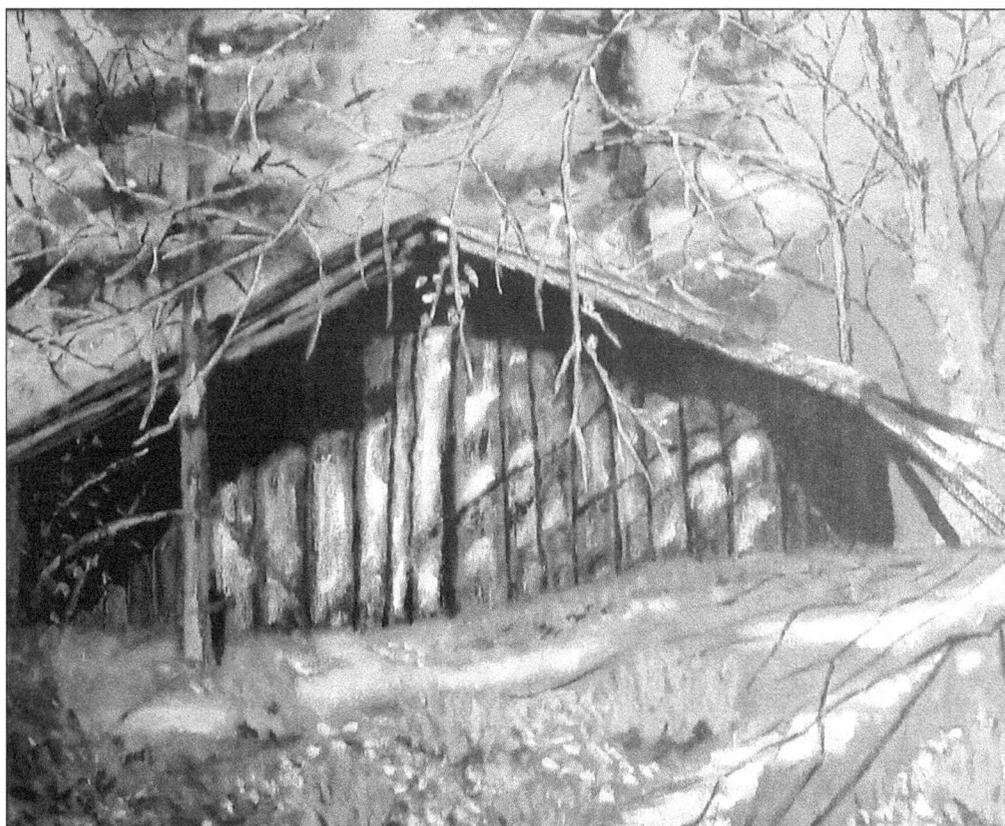

A Shasta Indian plank house was built over a three-foot pit. It had double walls for storage, and dirt floors. This painting by Mary Carpelan shows the house Roy and Joe Brodmerkle built 18 years ago at Betty Hall's place in Mugginsville, California. Some tribal men came to the monthly meeting, then they disappeared. They were sitting in the Indian house and were rejuvenated spiritually by the experience. (Courtesy Mary Carpelan.)

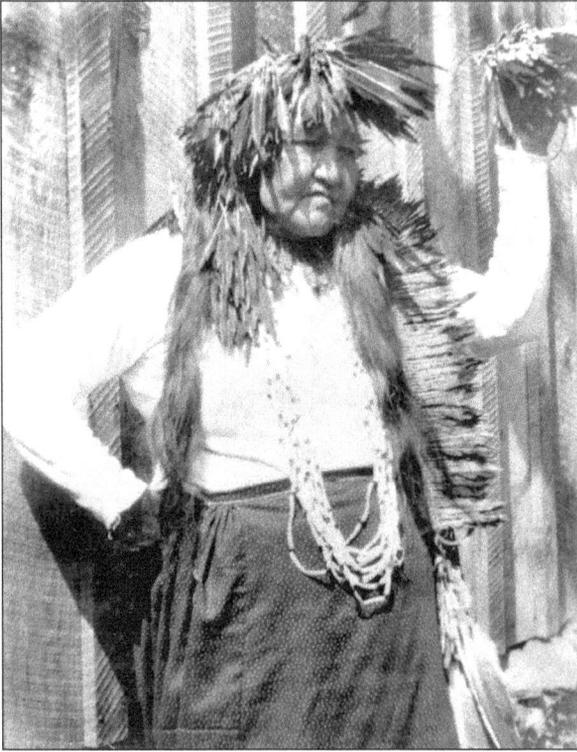

Jenny Prickle, shown here, was a Shasta Indian medicine woman. She is wearing a necklace of dentalium shells and Hudson Bay trading beads. The flicker feathers she is wearing were used extensively for ceremonies on headdresses and chest bands. This is all part of their sacred ceremonial costume. (Courtesy Kathryn Beatty.)

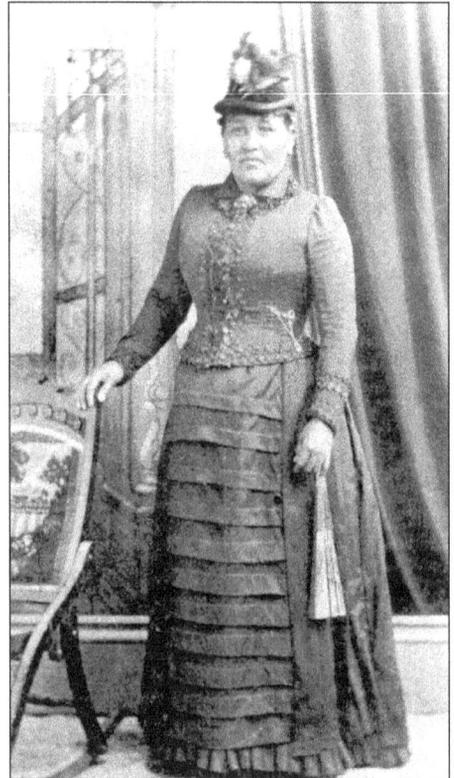

Pictured here is Jenny Kettlewood Ruff Keaton Preckle (who was married four times) in her white finery. When we are asked if the Indians assimilated into the larger culture very well, it looks like Jenny Preckle did, at least some of the time. Some of Jenny's baskets are displayed at the Smithsonian Institution in Washington, D.C. Jenny is an ancestor of Kathryn Beatty, Nancy Streeter, and Jim Falkoski. Jenny was born near Scott River in 1845 and died at Moffitt Creek in 1915. (Courtesy Katherine Beatty.)

Margaret Kettlewood, shown here, was part of Jenny Preckle's family. They moved around a lot and much of the family history has been lost. (Courtesy Nancy Streeter.)

Irene Hafner graduated from Sisters Hospital in Sacramento in 1917. She and her family moved around a lot and she always found work. Irene's daughter, Mary Brubaker, loaded up her three grandchildren and traveled to the Smithsonian to show them their great grandmother Jenny Preckle's baskets that were there on display. She brought Betty Hall a picture of the basket display. (Courtesy Nancy Streeter.)

Kathryn Beatty served in the U.S. Women's Army Corp from 1960 to 1963, Rank SP4, Secretary School, Fort McCullian, Alabama. Stationed at Fort Dix, New Jersey, she worked in the Army Education Center. Kathryn was standing in the chow line for breakfast one morning when a sergeant asked if she could shoot a gun. When Kathryn said yes, he said to be at the rifle range at 1800 hours. (Courtesy Kathryn Beatty.)

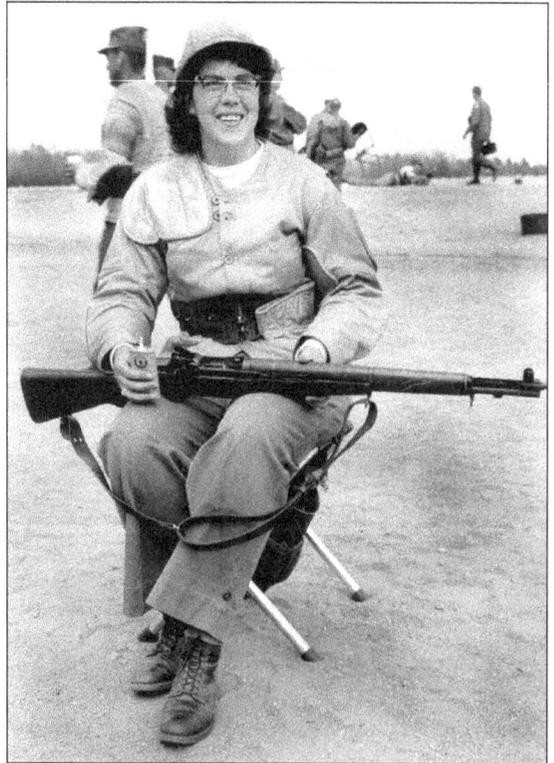

Kathryn went to the range and soon she was traveling the East Coast in competition with other military bases from West Point to Fort Benning. The national championships were held at Camp Perry. The ranges were 100 yards standing, 300 yards rapid fire prone, 300 yards sitting, 600 yards prone. There was a special 1,000-yard range and she hit the target 3 to 4 times out of 10 shots. (Courtesy Kathryn Beatty.)

Kathryn (Ruff) Beatty, seen here in the 1970s, stands beside the truck she drove for Arrow International throughout the United States. Kathryn worked at the Karuk Clinic in Fort Jones with Betty Hall in the late 1970s. When Kathryn left the job, she shocked her co-workers when she announced, "I am going to take truck-driving lessons and drive truck." (Courtesy Kathryn Beatty.)

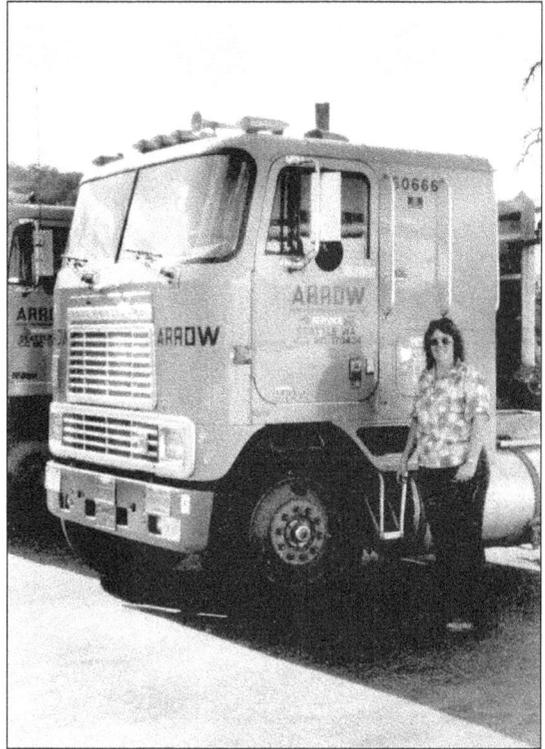

Lawrence Burcell is seen here as a young man in the early 1920s. His mother was Sallie (Much) Burcell. He is wearing a traditional headdress and band decorated with flicker feathers. This regalia was buried with William (Bill) Burcell, Lawrence's brother. Much of the Shasta regalia was buried with the elders and only a few photos remain. (Courtesy Kathryn Beatty.)

Fred Ruff came to Betty's home to be interviewed by Brian Daniels, ethnographer, regarding the re-licensing of the dams on the Klamath River by Pacific Corporation in June 2004. Fred is an avid angler and has fished the full length of the Klamath River. Fred told Brian about the water and fish conditions of the Klamath and its tributaries, and how they have changed over the years. (Courtesy Betty Hall.)

Pictured here, from left to right, are Charles Beatty, Susan Beatty, Fred Ruff, Kathryn (Ruff) Beatty, and Charles Beatty Jr. c. 2000. The Ruff family had an allotment on Duzel Creek up Moffitt Creek. The land was rocky, with poor soil. The government said they would improve the allotments, so the Ruff family abandoned their allotment with the promise of better land in Scott Valley. A new allotment was never assigned. (Courtesy Kathryn Beatty.)

Kathryn Beatty, shown here c.1995, always has a big smile and laugh, and she still enjoys shooting. She recalls that her best shot in the army was the 600-yard prone. The one she remembers best was a 300-yard rapid fire prone 9X and one 10 that covered a dime. Her favorite firearm was the M1 rifle. She and Betty have been good friends for many years. (Courtesy Kathryn Beatty.)

Edna (Burcell) Ruff was raised on the Mary Burcell Indian allotment near Etna, California. She married George Ruff from the Shasta reserve on Moffett Creek, which was just over the hills east of Scott Valley. Her children are Fred, Johnny, Margorie, Mary, and Eleanor Ruff. (Courtesy Jim Falkoski.)

Eleanor Ruff (left) and Marjorie Ruff are pictured here. Marjorie is Jim Falkoski's mother. (Courtesy Jim Falkoski.)

Jim Falkoski, shown here in May 2004, is of the Burcell and Ruff families. His mother was Marjorie Ruff. Today Jim works for the Karuk Health Program. He comes by to see if Roy and Betty need any medications or assistance in any way pertaining to their health. Jim does this for the Native American Indian Elders, and provides transportation for this helpful program. (Courtesy Betty Hall.)

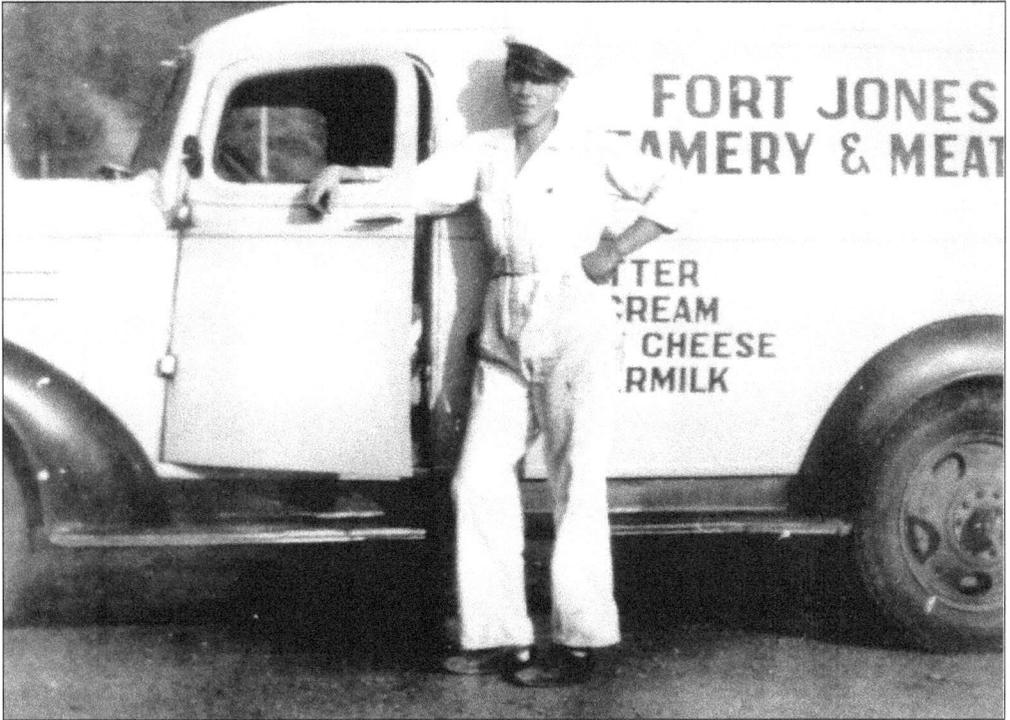

Fred Ruff drove the Fort Jones Creamery & Meat truck for many years. Fort Jones Creamery ice cream took first place at the California State Fair many times and was sold around the country in the 1920s and 1930s. In his later years Fred was a timber feller and now is retired. He spends his time hunting and fishing. Fred is the son of Edna (Burcell) Ruff. (Courtesy Jim Falkoski.)

Shown here from left to right are Edna Ruff's children: unidentified, Eleanor, John, Mary, Marjorie, and Fred. Fred lives in Fort Jones, and is doing very well. He spends his time fishing, hunting, and with his family. (Courtesy Jim Falkoski.)

Anna Brodmerkle is pictured here in 2003. In a press release dated May 27, 2003, it states, "The University of Idaho—Anna Lee Brodmerkle of Noxon accepted membership in The National Society of Collegiate Scholars and will be honored during a campus ceremony this fall at the University of Idaho." Anna did get accepted to Washington State University, and will continue her studies in veterinary science, starting in the fall of 2004. (Courtesy Anna Brodmerkle.)

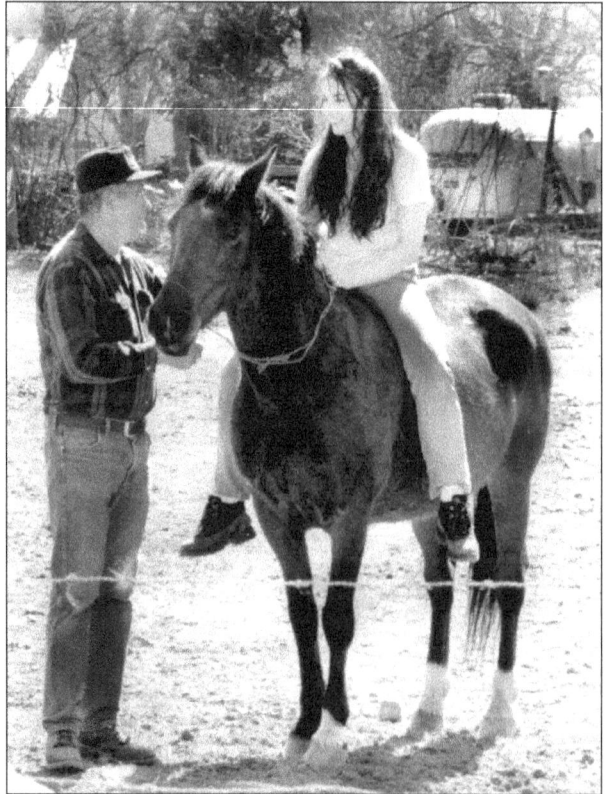

Robert McCallister, Anna Brodmerkle, and Kiaik are shown here in Mugginsville. Robert was giving Anna some pointers on using a Cherokee bridle to communicate better with her horse. He was always ready to lend a hand where a relative, friend, or a horse was concerned. He helped his nieces and nephews learn to ride and care for their horses and took them on pack trips to the mountains. (Courtesy Betty Hall.)

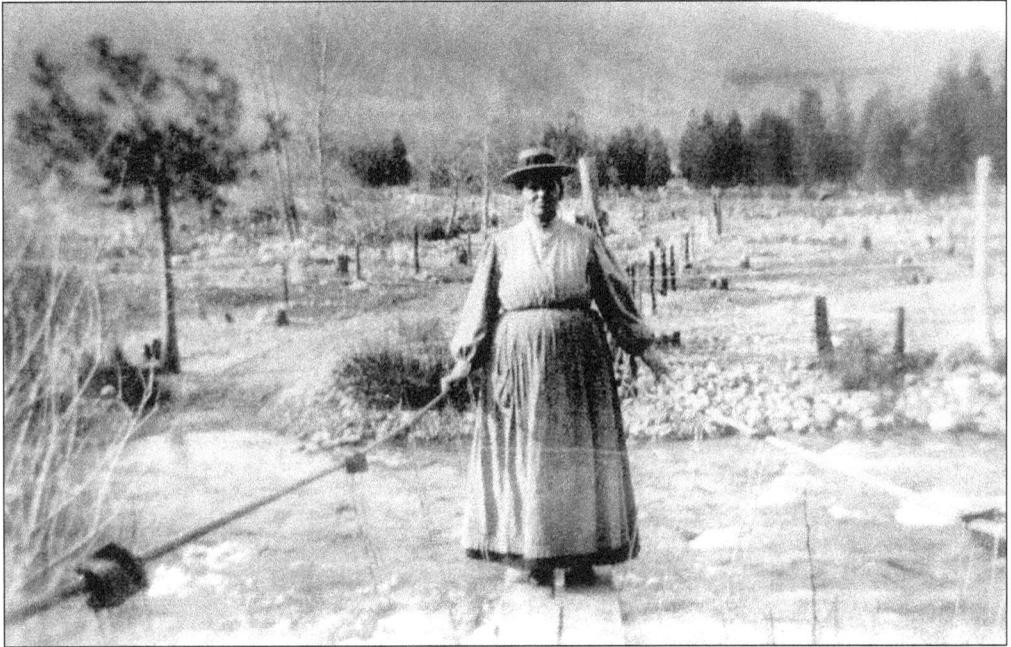

Sally Burcell is seen here crossing a footbridge over Etna Creek flood waters on Sally's mother's Indian allotment near Etna, California, in the 1920s. This rocky creek bed is a good example of the type of land allotted to Indians to sustain their families. Sally and Al Burcell had 11 children. Sally's mother, Mary, was born here. Her brother Squirrel Jim was just a small boy when white people came. (Courtesy Jim Falkoski.)

This photo shows a Shasta Indian sweat lodge on the Burcell allotment in Etna, California. Shasta Indians from all over Scott Valley came to use this lodge. (Courtesy Jim Falkoski.)

Mike Gomes is a son of Mary (Burcell) Gomes. He grew up on his grandmother Sallie Burcells' allotment near Etna. Mike has worked in the woods since high school and continues to log today. He and his family hunt often with the Griggs family and always have a good story to tell. (Courtesy Jeanie Griggs.)

Nicole Matney, at left, and Cody Matney are the twin children of Mercedes (Gomes) Turner. They live in Lewiston, Idaho. Mercedes brought her twins to visit with Betty Hall and learn more about their Shasta heritage in the summer of 1999 when they were 16. This picture was taken in Betty's yard next to a one-ton obsidian boulder Betty purchased from an Oregon rock quarry. (Courtesy Betty Hall.)

Tahj Gomes and his mother, Martha Gomes, are seen here at his graduation from Santa Clara University School of Law in 2002. The Shasta tribe is very proud of this young attorney. Times are changing, and many young Shastas who were raised in families that have been supported for the last few generations by logging are going to college and finding occupations in which they can make a living and a difference. (Courtesy Martha Gomes.)

The entire Gomes family traveled to Santa Clara University School of Law in 2002 to watch Tahj receive his degree. Tahj is currently working for a law firm in the San Francisco Bay Area. (Courtesy Martha Gomes.)

Flint Griggs, Tanner Griggs, Mike Gomes, and Ryan Gomes, seen here from left to right c. 2002, are doing what they like best—heading out early to their special hunting spots and bringing home fresh deer meat and a nice set of horns. Many Shasta families still depend on the deer and fishing seasons to provide most of the meat they will eat each year. (Courtesy Jeanie Griggs.)

Terkle and Sharon McBroom are hunting in this photo. Sharon says, "You can see what is important to our family." Almost all the photos Sharon brought for this book included hunting. This is true of most Shasta Indian families. Hunting and gathering are traditions that have helped us survive and have kept the tribal bonds of our families strong through good times and bad. (Courtesy Sharon McBroom.)

Julia Goodwin Stanshaw Johnson and her friend Frank Ruffy are seen here at a celebration in front of the Old Etna High School in the 1920s. Frank, who saw the first white man come to the valley, told of a great earthquake here before the time of contact. He said Shasta Indians were living in caves at the time and thousands were killed. The Shasta never lived in caves again. Frank was granted a 600-acre reservation near Etna. Frank died at age 115 and is buried in the Ruffy cemetery. (Courtesy Bernita Tickner.)

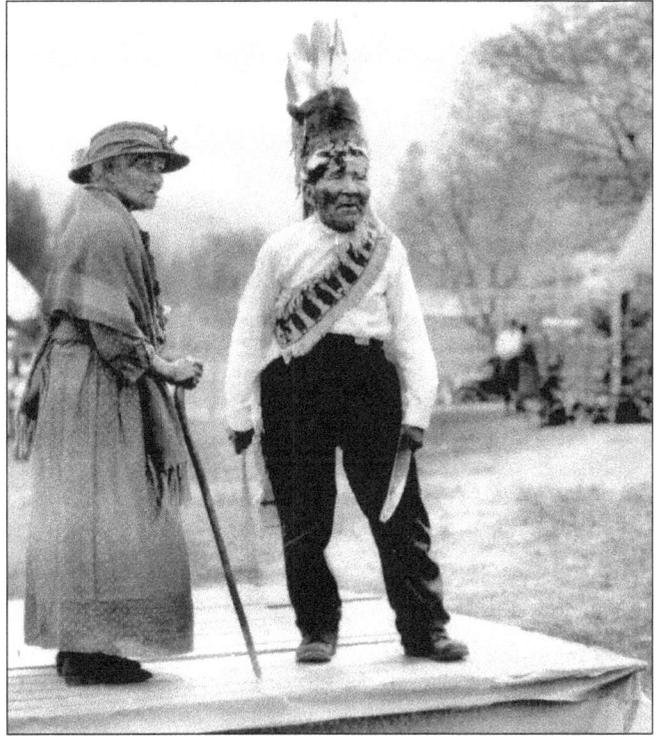

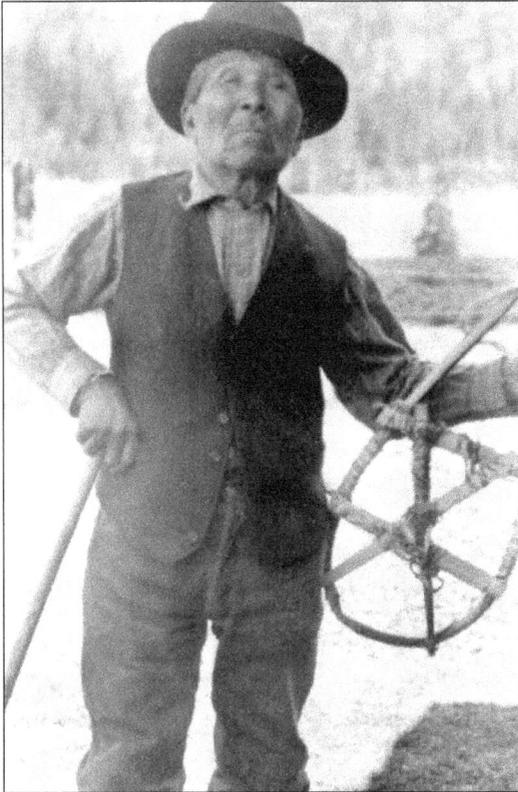

Charlie Ruffy is holding a pair of snowshoes wrapped with deer fur to make a wider pad and prevent slipping in the 1920s. Charlie worked on ranches and cut wood. He located a signal tree there on the Ruffy reservation. It had limbs on the bottom, then a bare trunk, with a 20-foot tuft on top. These trees were used to signal that a chief lived nearby. (Courtesy Bernita Tickner.)

Sissy (John) Bateman stands beside her granddaughter Ruby Pete. Sissy's father was Chief Hamburg John. With few soldiers to protect the Indians, vigilantes hunted them mercilessly. The captain from Fort Jones tried to stop vigilantes from killing Hamburg John, but arrived too late. He was shot when he stepped outside and his house was burned down. Sissy married Mr. Bateman and lived in Scott Valley. (Courtesy Betty Hall.)

This photo shows Wilson Pete and his grandson Glenn Hall. Wilson's Indian allotment was at Walker Bar near Seiad. When Wilson's family left their land temporarily to hunt around 1905, white people moved in and told him to leave. Wilson's family moved to Tyee Jim's village in Quartz Valley. Mandy McCallister was six years old and remembered crawling out of a makeshift tent that winter to shake the snow off. (Courtesy of Roy Hall Sr.)

Shown here from left to right are Glenn, Roy, Laura Hall, and Frank Wilson when they lived at Soap Creek *c.* 1936. Herman Hall was a logger and miner and worked hard to provide a home for his large family. They moved to the Yreka area when Herman became ill. (Courtesy Roy Hall Sr.)

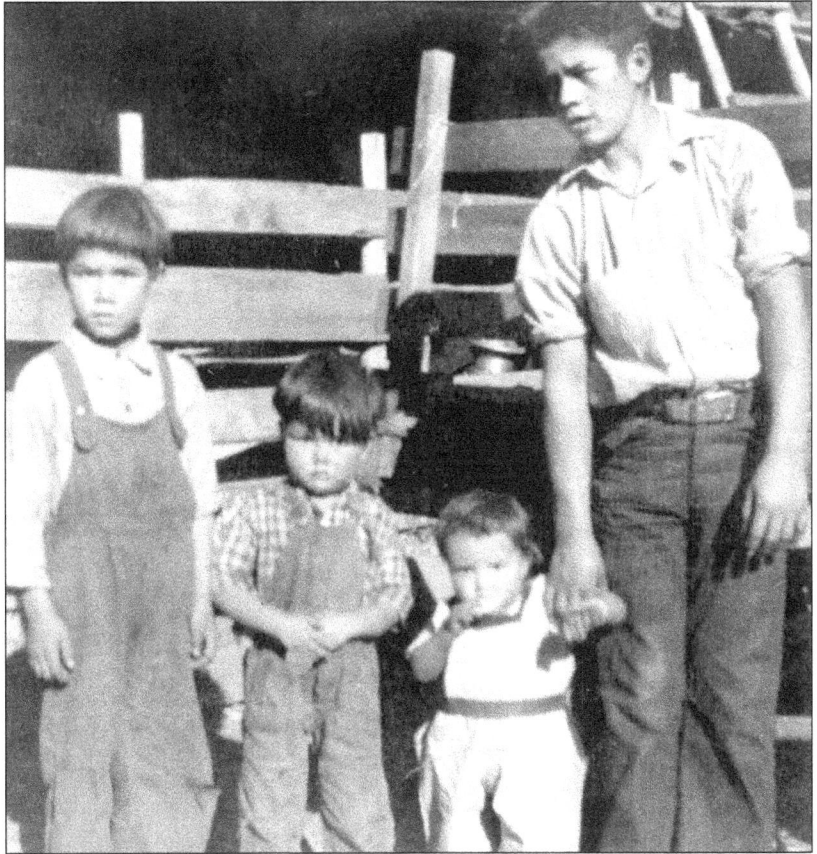

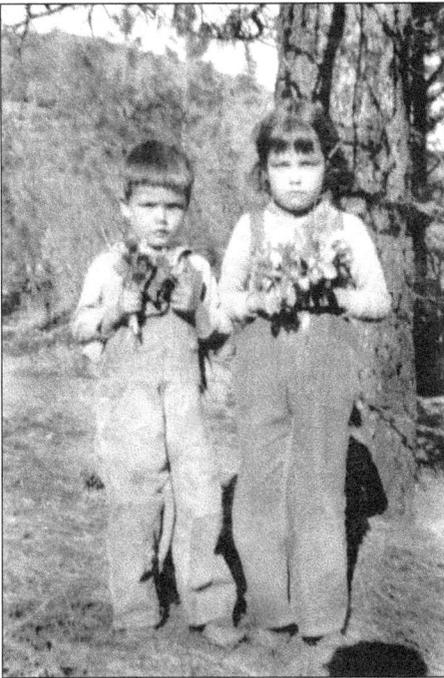

Roy and Virginia Hall are picking flowers *c.* 1937. They look so cute but they are probably trying to get back in the good graces of their mother for something they should not have done and hope she never finds out about. Like the time Roy hooked jumper cables from the car to the clothes line. (Courtesy Roy Hall Sr.)

Ruby (Pete) Stroud was the daughter of Wilson and Nora (Bateman) Pete. Betty Hall knew her when she lived with her sister Mandy McCallister in Oro Fino for a while in the 1950s. Ruby lived a hard life and struggled to raise her children. (Courtesy Roy Hall Sr.)

Claudine Pete, Stanley, Harriet, Marie, and Ruby Stroud sit on a large rock. Claudine was the daughter of Ruby's sister Ida. Claudine was killed in an auto accident when she was 10. Stanley lived with Betty Hall's family when he was in high school. He was killed in a truck wreck. Harriet lived with her aunt Mandy McCallister and Marie lived in the San Francisco Bay Area. (Courtesy Roy Hall Sr.)

Frank O. Wilson, seen above
c. 1942, served in the Navy
in the Pacific after the Pearl
Harbor attack. Frank was Roy
Hall Sr's. half brother. He later
worked for Pine Mountain
Lumber Company as a loader
operator for many years. He
married Maureen Sargent
and had one son, Frank Jr.
(Courtesy Roy Hall Sr.)

Frank Wilson is shown here as a young boy c. 1924 with his cow harnessed up to a cart loaded with wood. As the oldest child he was expected to gather wood to keep the cook stove going. There was always something to keep warm in case someone came in hungry. This picture was taken up Soap Creek, on the west side of Forest Mountain. (Courtesy Roy Hall Sr.)

Mandy, Robert Roy, and Robert McCallister are shown left to right *c*. 1940 in Oro Fino. Mandy was told by her children's teachers that speaking the Shasta language at school would not be tolerated. The school superintendent and county probation officer came to take the children to Chemawa Indian School near Salem, Oregon. Mandy told them, "You are not taking my children anywhere." Her house was clean and the children well cared for, so they stayed. (Courtesy Roy Hall Sr.)

This photo shows Roy Hall Sr. and his brother Robert McCallister at Fred and Nina Wicks's home on the Quartz Valley Shasta Indian Reservation. Betty and Roy were living there while her parents spent the winter on the Torres-Martinez Reservation in Southern California. They took care of eight hounds and two horses. There was seven feet of snow the winter of 1951–1952. Robert had one son, Dawson. (Courtesy Betty Hall.)

William Herman Hall, known as Herman, was Mandy McCallister's second husband. They had five children: Glenn, Virginia, Roy, Laura, and Elda. Herman died of cancer before Elda was born. Roy says he does not remember his father. (Courtesy Betty Hall.)

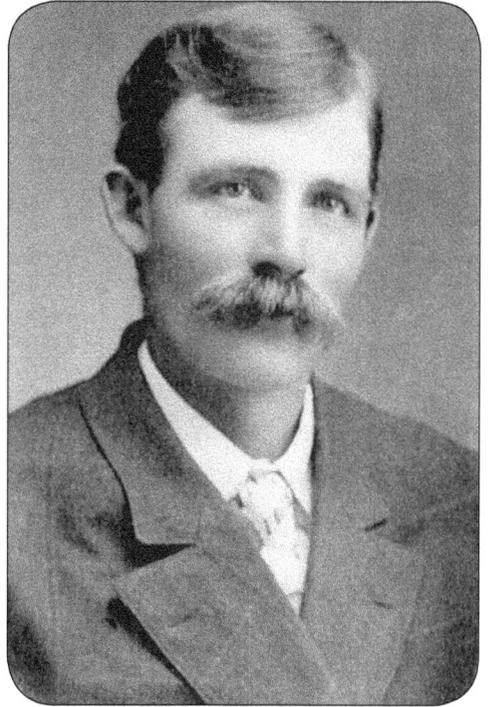

Glenn, Mandy, and Virginia Hall are pictured here at their home on Moffitt Creek c. 1932. The children learned young how to fish, hunt small animals, trap birds, and gather edible native plants to supplement a small garden and have enough to eat during the Depression. Life was hard, but they all pulled like one to keep the family together and fed. (Courtesy Roy Hall Sr.)

This is Glenn M. Hall's high school senior picture *c.* 1951. A few weeks after graduation, Glenn joined the army. He was based at Fort Ord, California, then he went to Fort Benning, Georgia. Glenn became a member of the First Ranger Company (Airborne), attached to the Second Infantry Division. Glenn was killed in Korea a few days after his 21st birthday. (Courtesy Roy Hall Sr.)

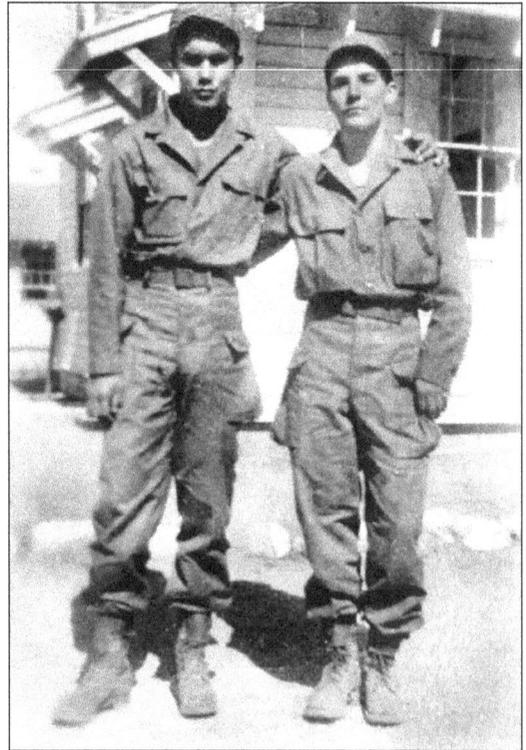

Glenn M. Hall and Henry McBroom are pictured here at Fort Ord, California *c.* 1951. This was the last time Henry saw Glenn. In a heated battle in Korea, Glenn was ordered to contact a friendly knoll, and found it occupied by the enemy. He tenaciously held the position and single-handedly secured the flank of his platoon. For this he received the Distinguished Service Cross and a Purple Heart. (Courtesy Henry McBroom.)

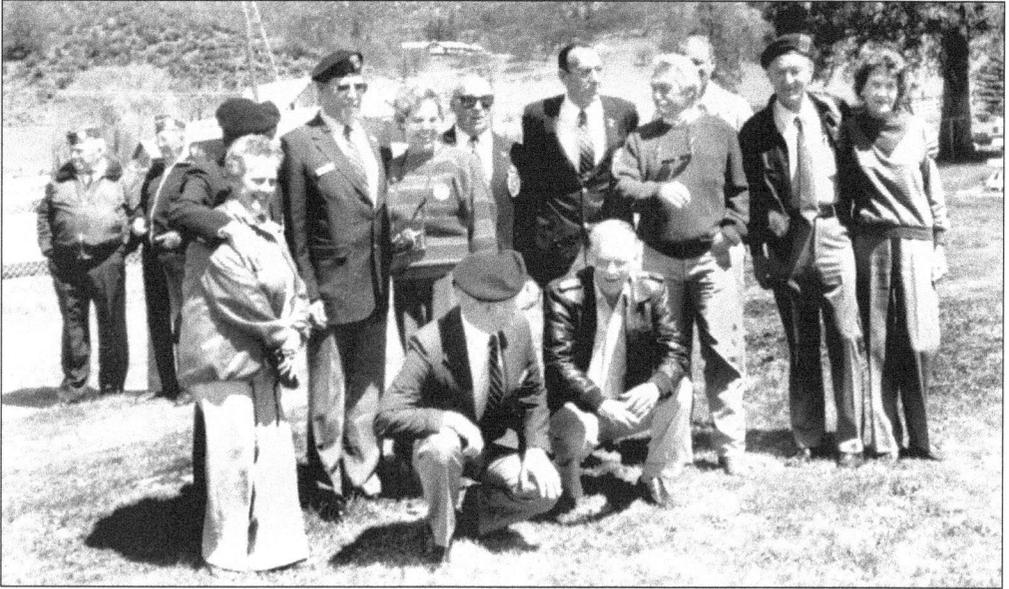

The Airborne Rangers honored Glenn Hall as their hero and came to Fort Jones to place a specially made Airborne Ranger headstone on Glenn's grave. Many were close friends of Glenn's and owed their lives to his bravery. They then traveled around the country placing similar headstones on the graves of other Airborne Rangers. State Senator John Doolittle sent a letter that was read at the service. (Courtesy Betty Hall.)

Henry Chester McBroom, is shown here in Old Etna c. 2004. In 1951 Henry and Jim Smith were on their way to Yreka to enlist in the army when they saw Glenn Hall walking and gave him a ride. At the time Glenn had no thought of enlisting. That evening they were in Fort Ord. Henry's service record: Fort Ord, California, Honolulu, Hawaii. 15th Base Office. 8285th. SU, Headquarters & Headquarters Company, United States Army in the Pacific Command, APO958. 6230th. RC. Fort Ord, California. (Courtesy Betty Hall.)

This picture of Mandy (Pete) Wilson Hall McCallister was taken in Greenview, California c. 1970. When they were growing up, Betty spent a lot of time at her house with Laura Hall, who later became her sister-in-law. She kept a neat home and made fabulous homemade bread. Betty married her son Roy, and he liked homemade bread so much that Mandy taught Betty how to make it. (Courtesy Virginia Thom.)

Mandy McCallister, and Frank, Carl, Jennifer, Bob, Monica, and Roy Hall stand in Betty Hall's yard at a party for Grandma Mandy's birthday c. 1985. Most of Mandy's children, grandchildren, and great grandchildren attended. Roy had just sold his logging truck and was felling timber near Big Meadows. Monica was raising their children and starting to write books. (Courtesy Monica Hall.)

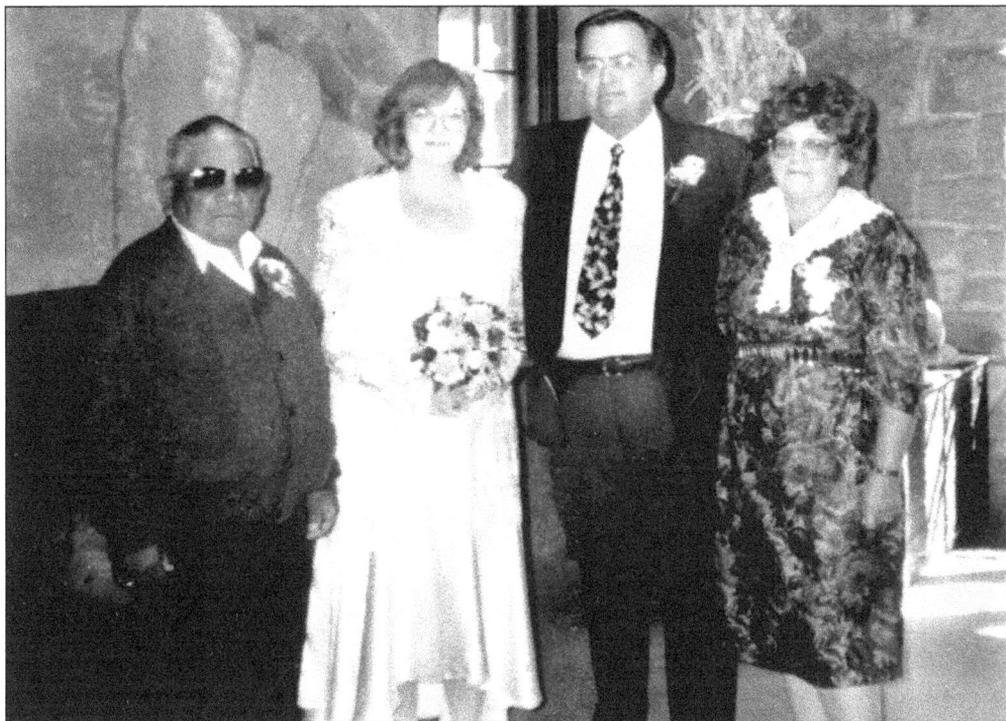

Shown here from left to right are Kelsey Thom Sr., Deborah Thom, Kelsey Thom Jr., and Virginia Thom at the wedding of Kelsy Jr. and Deborah at Pine Lake Lodge in Eldora, Iowa, on October 12, 1991. Now they reside in Thorton, Colorado. Kelsey is half owner of Pellet Mill Outfitters, in Commerce City, Colorado. Pellets are primarily for animal feed. Kelsey travels around the world setting up these pellet mills. (Courtesy Virginia Thom.)

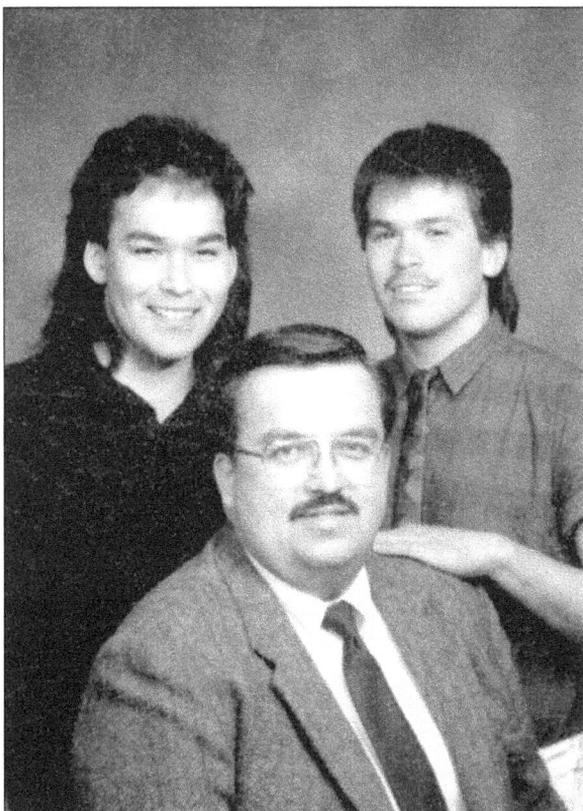

Kelsey Thom Jr. (front) and his sons Jason and Barry are shown here. Kelsey graduated from Etna Union High School. He attended Heald Business College and studied drafting. He was employed in the San Francisco area for a time and married Carol Matteoli. They lived in Marin County, California, for many years then moved to the Midwest. (Courtesy Virginia Thom.)

Laura and Don Bailey, shown here in the 1980s, lived in Salem, Oregon. Laura was the sister of Roy Hall, Elda Alford, and Virginia Thom. Laura worked in the state offices at the capitol building and in the food-stamp department. She met Don in the vegetable section of the local grocery store. Laura removed walls and remodeled their house and Don grew the best vegetables Betty Hall has ever seen. (Courtesy Virginia Thom.)

Lester Alford Jr. and Lester Alford III are pictured at the University of Phoenix, in Sacramento, California c. 2000. Lester Jr. has just received his masters degree in business management. Lester Jr. had a long career in the Marines and continued his education through the years. Lester III has also been in the Marines. Now they both live in Hoopa, California, where Lester Jr. recently married Jacqueline Marshall. (Courtesy Linda Navarro.)

Betty and Roy Hall Sr. are heading for Roy Hall Jr's wedding. He married Monica Jae Slette in the Catholic Church at Fort Jones on June 19, 1976. Roy Sr. was employed by International Paper Company for 22 years. Betty was a medical receptionist for the Shasta-Trinity Rural Indian Health. They have seven children: Brenda Brodmerkle, Linda Navarro, Mary Carpelan, Roy Jr., Nina Cossey, Bill Hall, and Glenn Hall. (Courtesy Betty Hall.)

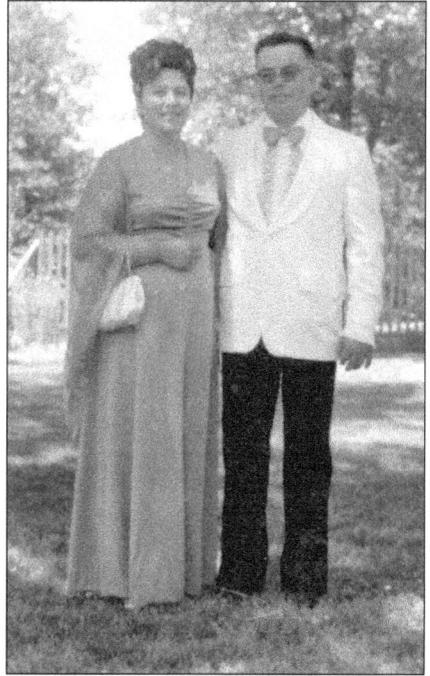

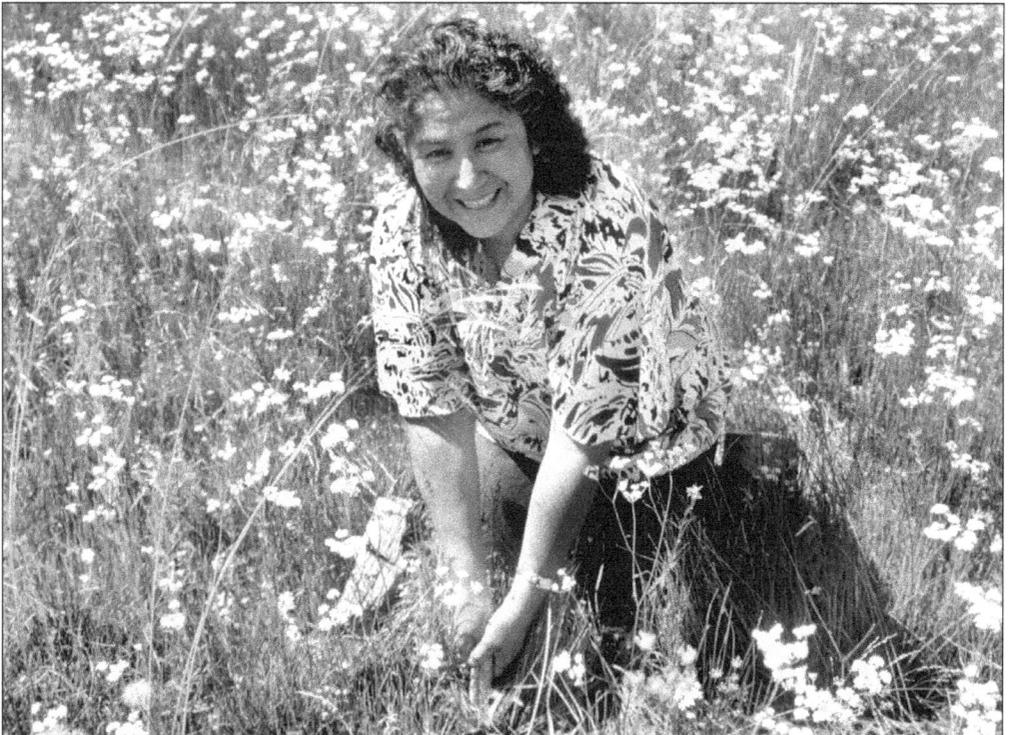

Betty Hall is digging in a meadow of epos close to the Upper Klamath River. Archaeologist Joan Mack and Mary Carpelan brought Betty there. Betty had been looking for epos, which is a bulb that is a mainstay of the traditional Shasta diet. They have a pleasant, sweet smell. The bulbs were baked for 24 hours in an earthen pit, then pounded into flour. (Courtesy Mary Carpelan.)

Pictured here are Anna Brodmerkle and Kiaik, which means "dream" in the Shasta language. Anna fell in love with this beautiful Morgan and after ten years convinced her aunt Monica Hall to sell him. Anna and Kiaik live in Idaho and Monica gets to visit. Anna and Monica communicate often and share stories about their dream horse. (Courtesy Monica Hall.)

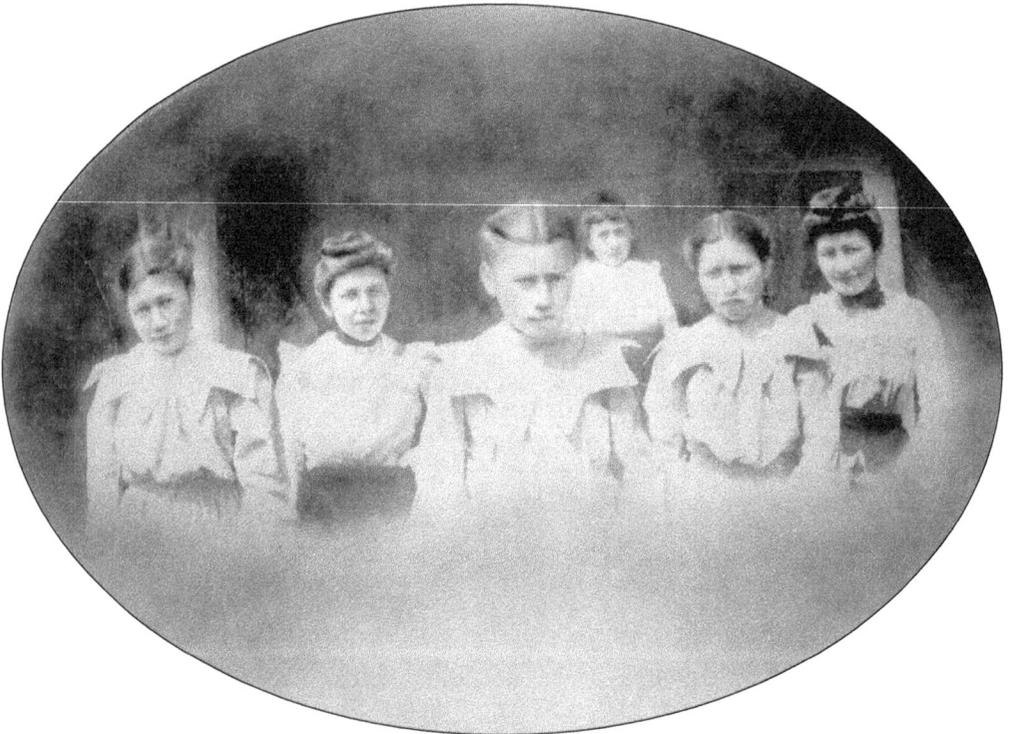

Seen here c. 1910, from left to right, are Carrie, Clara, Nettie, Arthur, Grace, and Bessie Wicks, who were the children of Charles and Margaret Wicks. Grace and Bessie were attending Haskell Indian College in Kansas when Grace contracted pneumonia. They were coming home on the train, but Grace died en route. Nettie and Grace were twins. Nettie died in her teens. Clara lived to be 99. Arthur married, had a daughter, and died young. (Courtesy Betty Hall.)

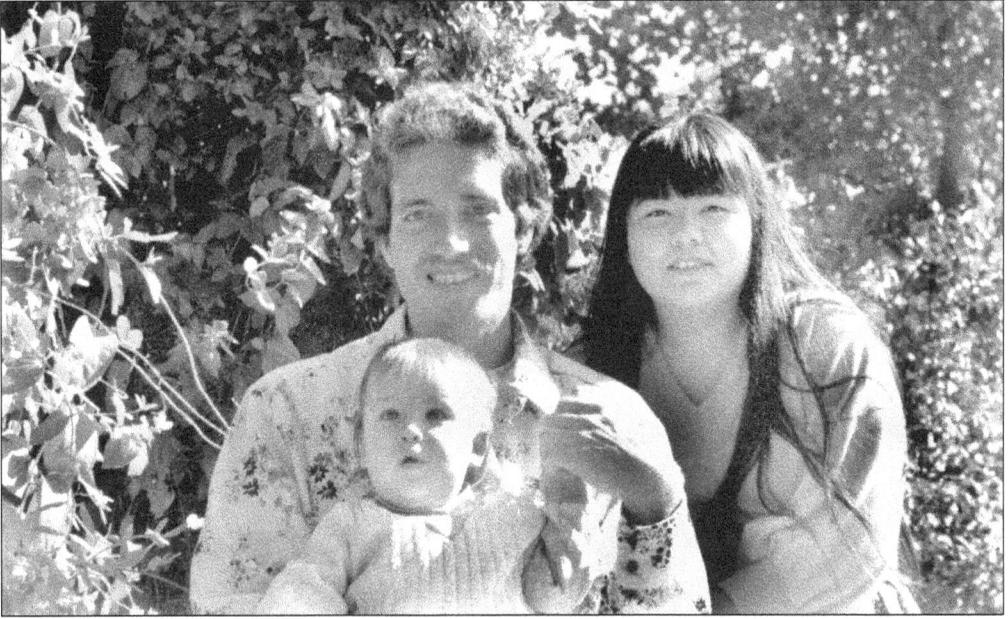

Eric, Mary, and Lars Carpelan pose at the home of Mary's parents, Roy and Betty Hall, in Mugginsville. A few years ago Eric took his family to Finland to visit his sister and extended family. They had a great time. Eric is a mason by trade, and Mary has worked in archaeology for 18 years, and she also is a basket weaver and an artist. (Courtesy Mary Carpelan.)

Lars, Eric, and Mary Carpelan, seen here left to right, c.2002. Two years ago Mary began taking art classes. We knew she could draw quite well and soon she was producing beautiful scenes and portraits. She won Best-of-show in 2003 at the Siskiyou County Fair and has contributed two pieces of her art to this book. (Courtesy Betty Hall.)

Everyone poses for Father's Day 2004 at Frank and Monica Hall's home in Yreka. Frank's siblings, parents, nieces, and nephews attended. Shown here from left to right are (front row) Monica Hall, Sean, Miguel and Venice Hidalgo; (second row) Frank, Roy, Monica, Laura Hall; (back row) Carl Hall, Tony Hidalgo, Bob Hall, and Brian and Jenn Hidalgo. Frank is a mechanic, Monica a surgical assistant, Carl paints highways, Jenn is a nurse's aid, Bryan drives a delivery truck, and Bob is a firefighter. (Courtesy Monica Hall.)

The whole Hall family dressed up for a wedding c. 2003. Pictured left to right are Venice and twin brother Miguel Hidalgo, Laura Hall, Jennifer Hidalgo, Monica Jae Hall, Monica June (Sweezy) Hall, Frank Hall, Roy Hall Jr., Robert Hall, and Carl Hall. Frank and Monica's wedding took place in Dr. Breyner's beautiful yard on July 12, 2003, with the reception at Frank's grandparents, Harold and Mary Slette's ranch in Scott Valley. (Courtesy Monica June Hall.)

80

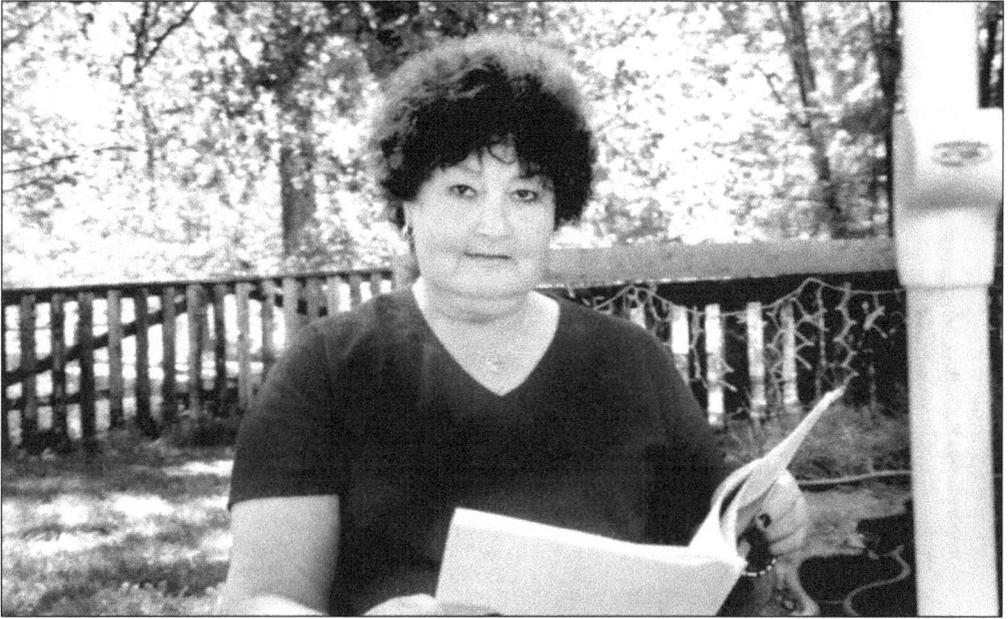

Elda (Hall) Alford looks up at the Hall family reunion and surprise 50th wedding party in 2003 for Roy Sr. and Betty, at their home in Mugginsville, Quartz Valley. Elda lives in Scott Valley and is employed at the Fairchild Medical Center in Yreka, California. (Courtesy Betty Hall.)

Elda Alford's family is pictured here after the funeral services of her husband, Lester Alford Sr., at the Fort Jones Community Center in Fort Jones, California. (Courtesy Betty Hall.)

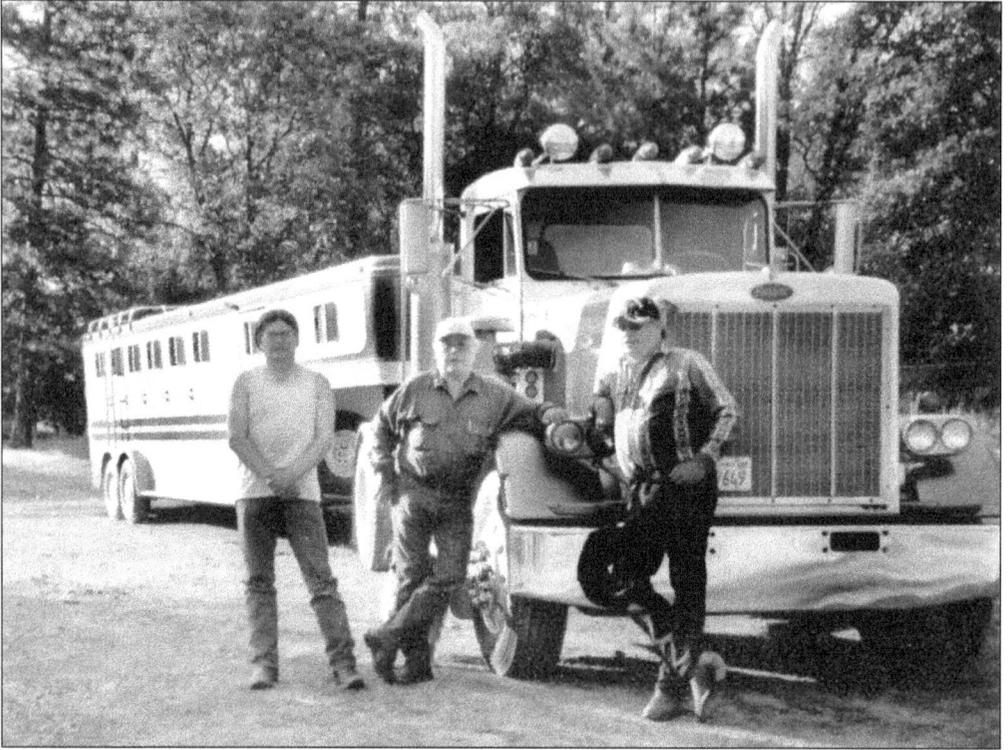

Standing here left to right are Roy Hall Jr., Roy Hall Sr., and Jim Prevatt, in front of Roy Jr.'s 1973 Peterbilt truck and six-horse trailer in June 2004. Roy Jr. works for HealTherapy for behavioral health and uses Parelli Natural Horsemanship and his own horses to assist clients in learning life skills. He is also a farrier, and the chairman of the Shasta Nation. (Courtesy Betty Hall.)

Robert McCallister and Patricia (Wilson) McCallister hug for everyone at their wedding reception in their front yard on Third Street in Yreka, California, July 9, 1978. Later they moved to Oro Fino. (Courtesy Betty Hall.)

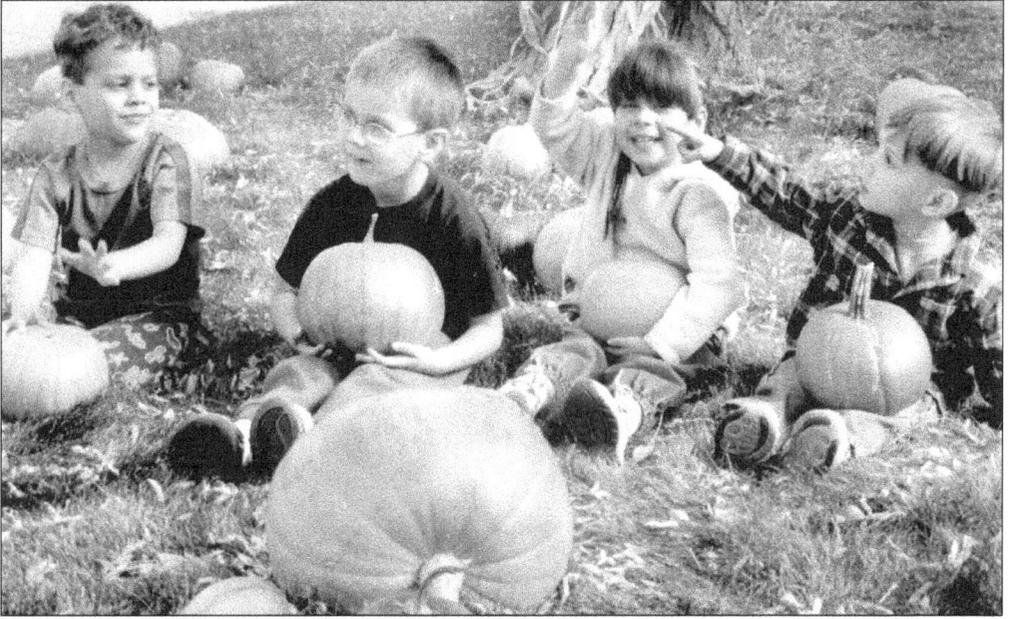

The Hidalgo children—Miguel, Tony, Venice, and Sean—enjoyed a day at the Pumpkin Patch in Gazelle. They are the grandchildren of Roy Jr. and Monica Hall. This farm makes acres of pumpkins available to the local schools and the children go on field trips to get the perfect pumpkin for Halloween. (Courtesy Jenn Hidalgo.)

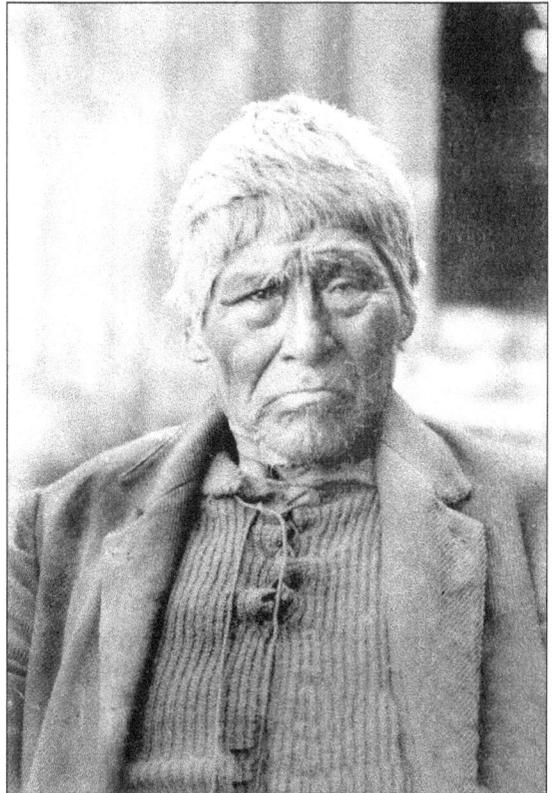

This is Chief Kimolly from Hamburg, California, c. 1880. The Shasta chiefs who were not killed in 1851 were taken out of the area to pacify the people. Kimolly went to Alcatraz. Eventually he was allowed to return. He was the grandfather of Margaret (Murree) Wicks and the great-great-great grandfather of Betty Hall. He is buried at Hamburg in an unmarked grave. Everett Conroy showed Betty the burial site. (Courtesy Oliver Brown.)

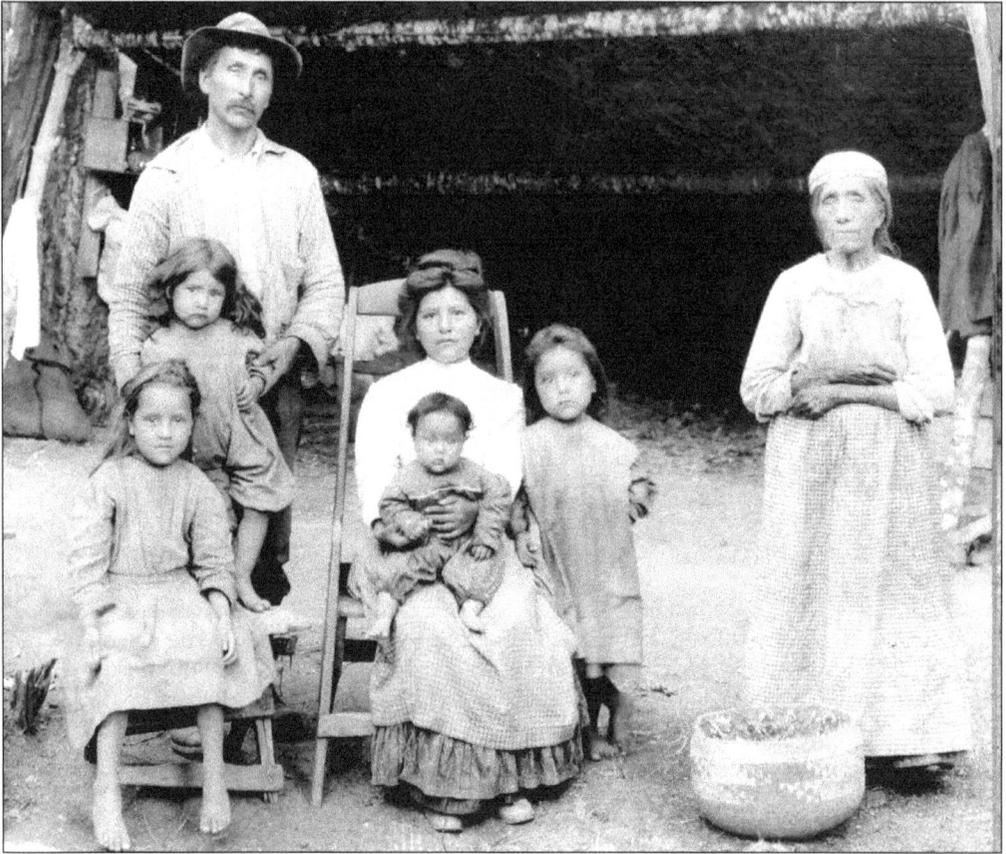

Charles and Margaret (Murree) Wicks and some of their children are shown at their ranch on Scott River in the 1880s. The elderly lady is Mary Kimolly, Margaret's mother, and the daughter of Chief Kimolly, shown on the previous page. The girl standing beside Margaret is Emma Weeks. Monica Hall found this picture two years ago, the only picture Betty Hall has ever seen of her great grandmother Margaret. (Courtesy Charlie and Pam Hayden.)

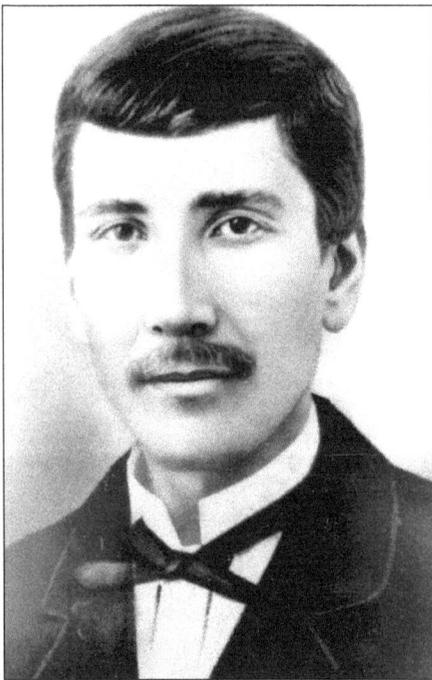

In this photo taken c. 1875, Charlie Wicks has just won a walk-a-thon in Fort Jones. The photo was made to put in the newspapers. (Courtesy Betty Hall.)

Jenny (Mungo) Wicks was born about 1820, where the Quartz Valley Indian Reservation is located, precisely at the site of the Clara Wicks land assignment. She and Ned Wicks had two sons, Charles and Joseph. Ned left Jenny and the boys to fend for themselves, went to Portland, and married the mayor's sister. Jenny later had a son, William Turk. (Courtesy Betty Hall collection.)

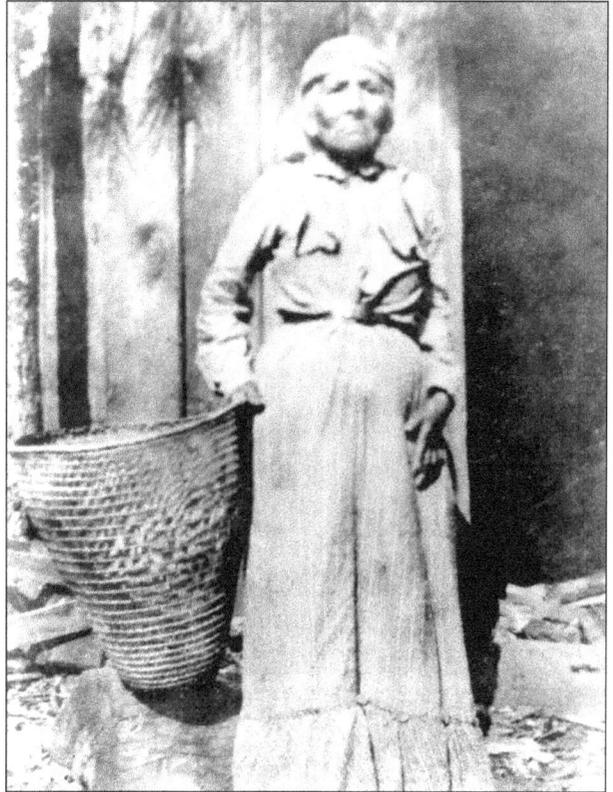

Pictured here are Roberta (left) and Roxanne Grant, daughters of Robert and Judy Grant of Yreka, California. Their skirts are decorated in beautiful patterns made of shells, pine nuts, and abalone. All are natural materials, which are customary for California tribal regalia. The girls are descendants of the Grant family of Salmon River. (Courtesy Robert Greant.)

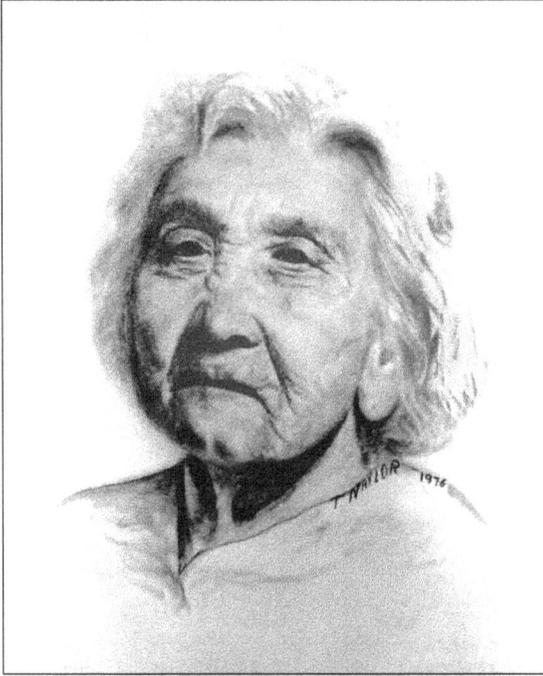

Miss Clara Wicks was Betty Halls' great aunt, shown here c. 1978. Betty spent her childhood with Clara, as she would take Betty and Tom Webster to gather herbs or fruit in the woods. Clara always carried a .22 rifle. They gathered wild plums, pipsissewa, and icknish (wild celery), which was Clara's favorite. She told Shasta Indian stories as they walked and gathered. She was born in 1879 and died 1978. (Courtesy Theresa Naylor, artist.)

Seen here from left to right are Betty Wicks, Clarabelle Black, Sam Black, Fred Wicks, Bill Turk, Fred Lee Wicks, and Alva Black at Lee Wicks home on the Quartz Valley Shasta Indian Reservation c. 1943. Bill Turk was the son of Jennie Wicks. At one time he was a peace officer on the Klamath River. He spoke seven Indian dialects along the Klamath River and on the coast. Clarabelle's father was Fred Wicks. (Courtesy Betty Hall.)

Tom Webster was in the army for several years and worked as a radio operator, specializing in Morse code operations. He returned home and lived on the Quartz Valley Shasta Indian Reservation with his aunt Clara Wicks, who had raised him after his mother, Carrie Wicks, died of peritonitis when he was two years old. He married and had one daughter, Joan. (Courtesy Joan Webster.)

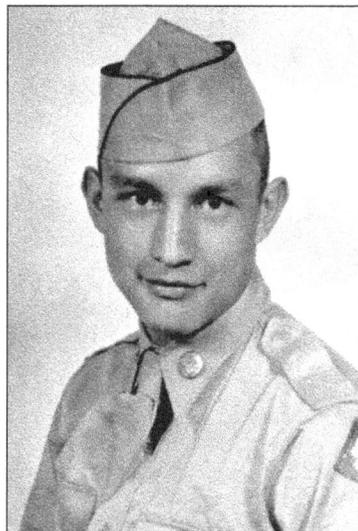

Joan Webster and her friend Dan Householder are seen here in June 2004. Betty just happened to see them at a yard sale and took this picture. Joan is Betty's cousin, the daughter of Tom Webster. She studies finance in college and works as an accountant, living in Durham, California. (Courtesy Betty Hall.)

Sharon (Sargent) Iverson, and Joseph Wicks stand on the main street of Mugginsville c. 1940. Joe lived near Blue Pond and later with Betty Hall's family on the Quartz Valley Shasta Indian Reservation. Betty sat on the floor while Joe told her Shasta Indian stories. Betty was too small to remember the stories, and no one wrote them down. Joe's sons Elmer, Herman, and Percy visited often. (Courtesy Sharon Iverson.)

Pictured here from left to right are (front row) Faye McCulley, Donna McCulley, Ike McCulley, Kenny McCulley, and Elmer Weeks; (back row) unknown. This picture was taken at the funeral of Herman Weeks at the Scott Bar Cemetery. Herman's brother Elmer conducted a very nice service. The family of Joe Wicks changed their name to Weeks to avoid confusion with the mail. (Courtesy Betty Hall.)

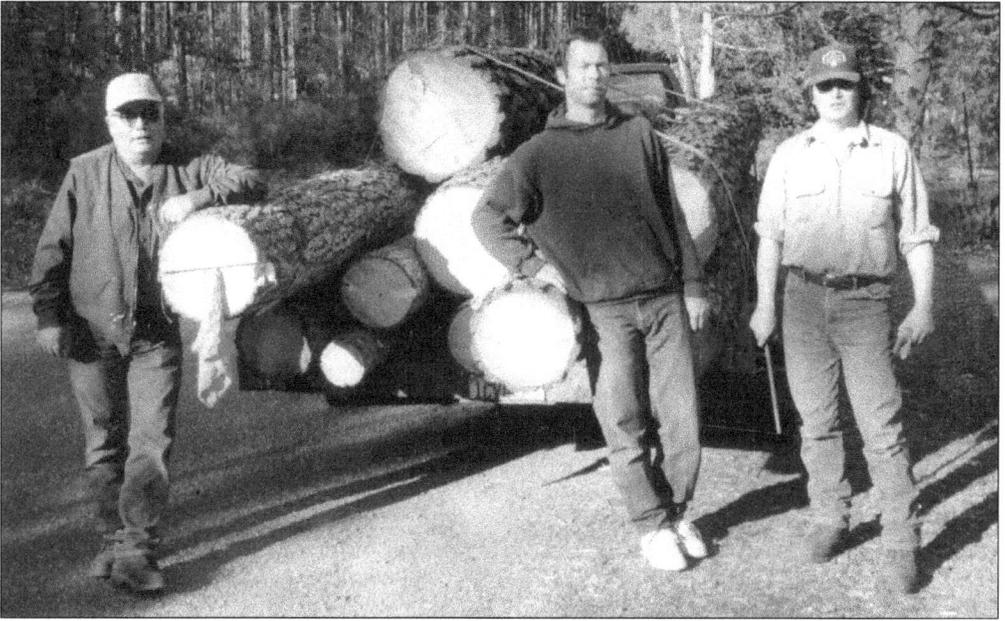

Left to right are Roy Hall Sr., Joe Johnson, and Roy Hall Jr. next to a load of wood logs from Cheeseville. Roy Sr. and Jr. built the flatbed trailer to haul logs, lumber, and cars. They built four-foot racks for hauling wood and they even built a removable eight-foot stock rack for hauling horses. (Courtesy Betty Hall.)

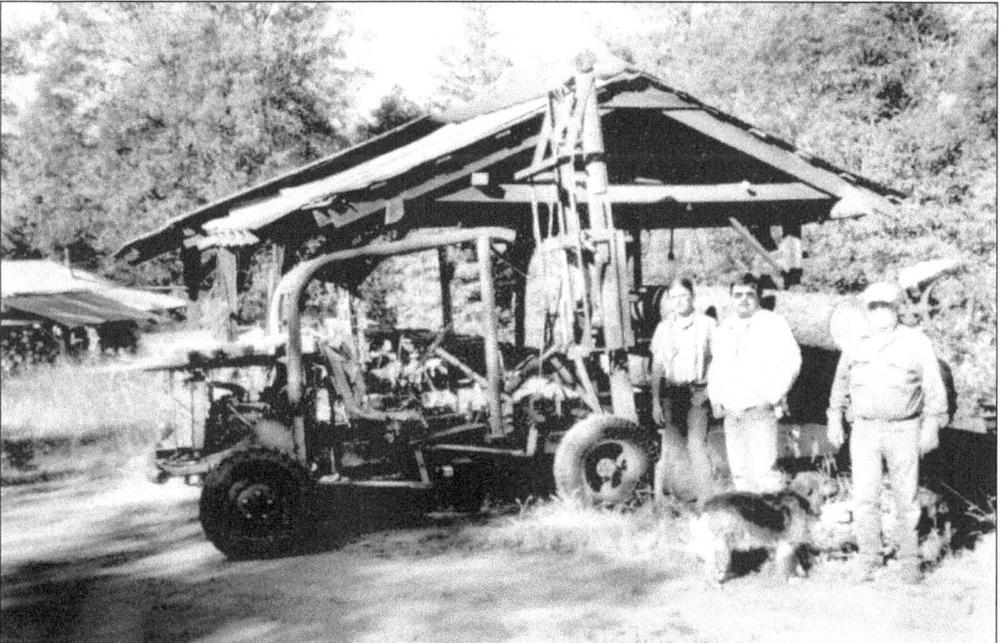

Roy Jr., Glenn, and Roy Hall Sr., shown here in June 2004, in front of the sawmill and loader Roy Sr. built from his own design in 1966. Roy sawed lumber for his outbuildings. In recent years he got an MSG (portable) sawmill, but likes the old quarter-curve standby. He sawed lumber for a cabin for Betty Hall's parents when they were elderly and needed Betty's care. (Courtesy Betty Hall.)

Shown from left to right c. 1988 are Sam Black, Betty Hall, Thelma Dollarhide, and Mike Engleman, all first cousins on the Wicks side. This picture was taken at Betty Hall's place after the funeral of her father, Fred Wicks. Sam has a construction business building roads, Mike is an airplane mechanic, and Thelma worked for 16 years for Litton Industries as a mechanic repairing Cruise and Tomahawk missiles. (Courtesy Betty Hall.)

Robert McCallister, left, and Gennady Kolosov, a historian from the former Soviet Union, are shown here at the Fort Jones Museum c. 1988. The Soviets were here to see and learn about Indian baskets, artifacts, and pioneer lifestyles. The Shasta delegation was Robert McCallister, Roy Hall Sr., Betty Hall, Jennifer Hall, and Roy Hall Jr., chairman of the Shasta Nation. The Karuk Delegation was made up of Carol Oscar, Raymond Oscar, and Beverly Dowling. (Courtesy Betty Hall.)

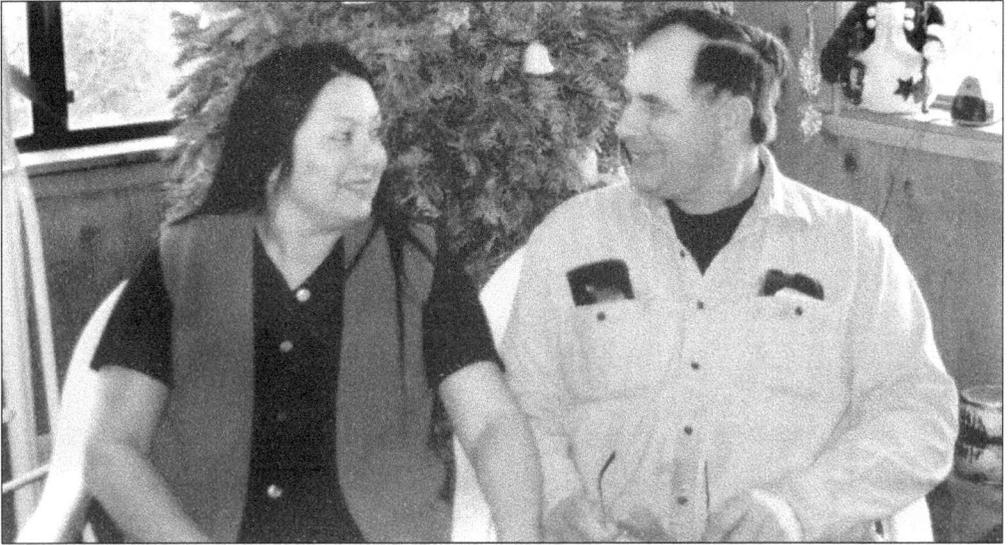

Brenda and Ron Brodmerkle are at home in Montana, Christmas 2003. They run a logging business in Idaho, Montana, and Washington. And the family hobby is hunting. When Brenda and Ron were married they went to Washington, D.C., where Ron was stationed as a Marine honor guard for President Nixon. He had already spent several years in Vietnam. (Courtesy Brenda Brodmerkle.)

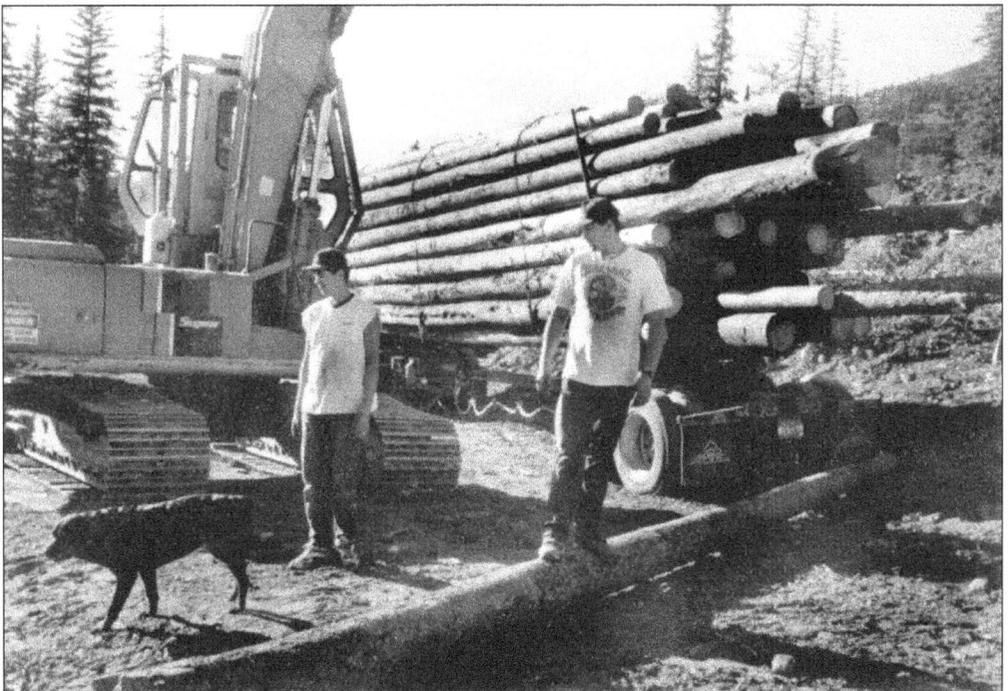

Roy and Joe Brodmerkle are seen here on a logging job in Montana. Roy fells and skids the trees to the landing at tree length, without cutting, and Joe operates a de-limber, sorting table, and log loader in the landing. When they aren't working or repairing their equipment, they spend their time with their families hunting and fishing and telling stories. (Courtesy Brenda Brodmerkle.)

This is Fred Lee Wicks's graduation picture at Sherman Indian School in Riverside, California. After graduation he continued his education in electrical engineering. Fred worked for a time as an electrician for the power company, and then he worked as a dairy farmer, turkey rancher, trapper, logger, timber feller, and gold miner. He established the Quartz Valley Shasta Indian Reservation and was a federal marshal. He is Betty Hall's father. (Courtesy Betty Hall.)

Nina Elizabeth Kintano lived the old Indian way in a thatch hut with a dirt floor and a fire in the center. She did not learn English until she was 15 years old and went to Sherman Indian School in Riverside. She attended Haskell Indian College in Kansas, became an English teacher, and taught in Phoenix, Arizona. She is Betty's mother and is Cahuilla from the Torres Martinez Indian Reservation. (Courtesy Betty Hall.)

This is what was written on December 27, 1982, about this photograph: "Dear Ron, Brenda and kids. I thought maybe you'd like these, was taken when we were younger. But now I look like something the cat druged [sic] in and your Grandpa looks like hell. We were going to have our pictures made for this Christmas, but he got sick, and so we had to have the old ones made . . . So long and Merry Xmas to you all. Grandma Nina." (Courtesy Brenda Brodmerkle.)

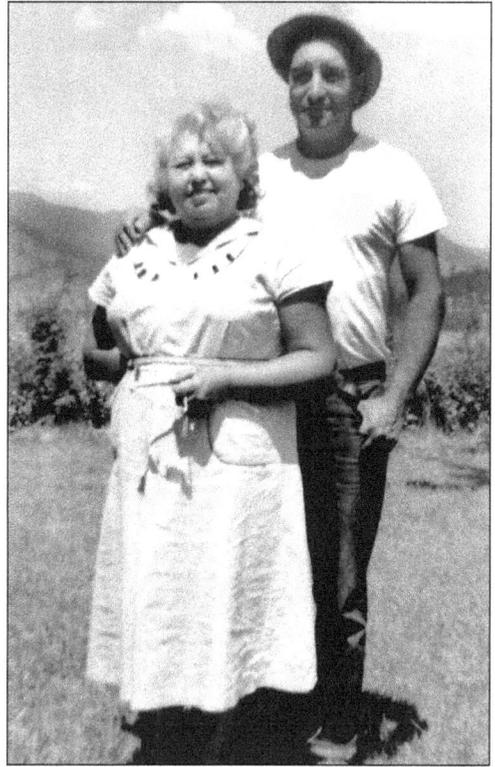

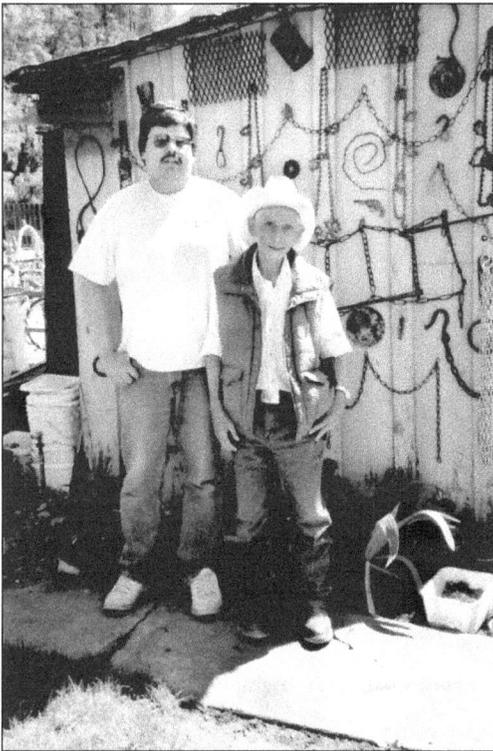

This is a photograph of Glenn Hall, left, and his friend Apache Joe, a.k.a. Joseph Oroso. There is a song written for Apache Joe, entitled, "Biggest Little Man I Know," a very fitting title. Joe is always there with a big smile and a hand to lend to anyone who needs help. This picture, c. 2004, was taken at Glenn's residence in Fort Jones, California. (Courtesy Betty Hall.)

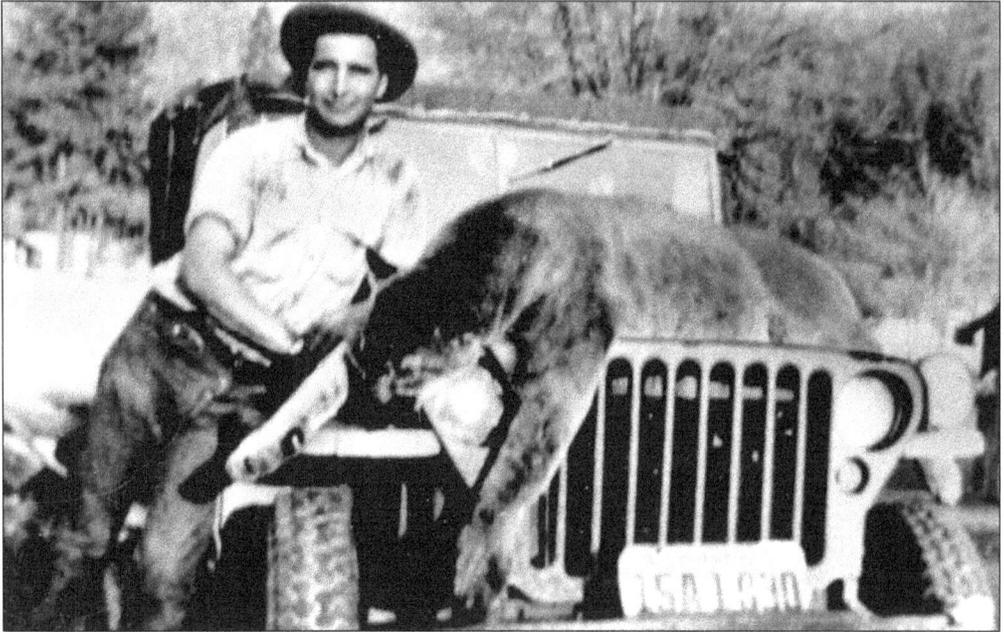

This photo shows Fred Lee Wicks and the mountain lion he killed below Happy Camp, California, c. 1949. Fred spent many years as a trapper and hunted big cats and bears for hides. His woodshed was decorated with many sets of deer horns, and he could tell you exactly where he had taken each buck, bear, or cat. This picture was taken at his Uncle Frank Murree's home in Happy Camp. (Courtesy Betty Hall.)

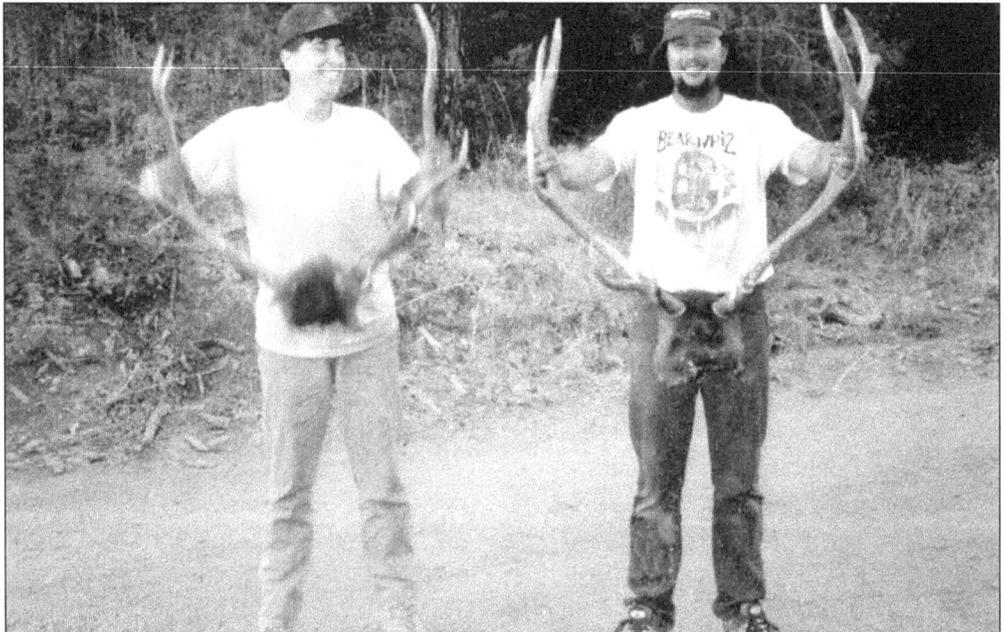

Joe Brodmerkle is six feet, five inches tall, and Roy Brodmerkle is six feet, four inches tall. Roy Hall Jr. said these boys make the elk antlers look small in this photograph taken c. 2002. This is what you can get in the north woods of Montana. Roy and Joe are both self-employed in the logging business. (Courtesy Brenda Brodmerkle.)

94

Mary Carpelan is seen here with the basket she is weaving in 2004. Mary learned to weave from her grandmother, Mandy McCallister. Mary had to gather her own willows, peel them and size them, but when Mary sat with her grandmother to make baskets, it was story time. Mandy said she and her grandmother, Sissy Bateman, would take weeks going around the valley gathering basket materials and herbs for medicine. (Courtesy Mary Carpelan.)

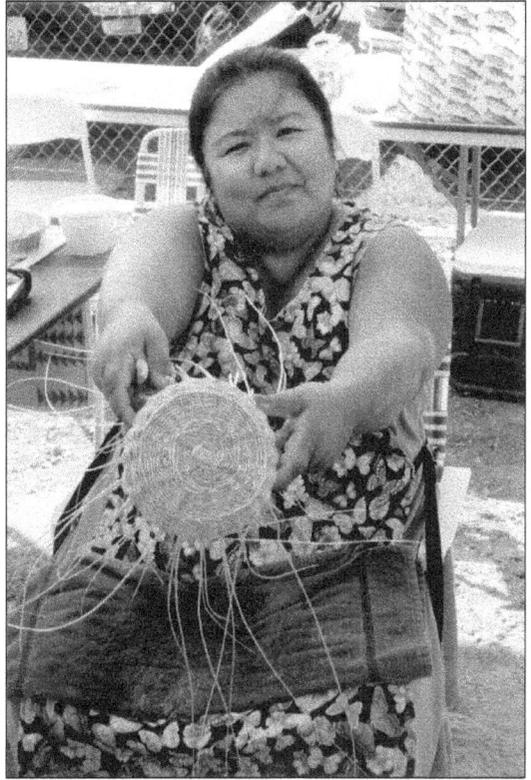

Larry Johnson, Joe Johnson, and Robert McCallister help Joe learn to ride in September 1972. Larry and Robert were lifelong friends and shared many trips to the mountains to fish and hunt. They both worked in the woods and had stories to share when they visited, which was often. Robert passed in January 2001 and Larry in September 2003. They are both missed by family and friends. (Courtesy Peggy Johnson.)

Nina Lorraine Hall is shown here at 23 months in 1957. Nina was born with Spina Bifida and Hydrocephalus, and is paralyzed. Doctors at Stanford said she could not possibly live more than two years. But with a lot of hard work, and her sisters helping, exercising her without any medical supervision at all, Nina took her first steps at the age of three. Nina went to college for two years! (Courtesy Betty Hall.)

Charles, Crystal, and Nina Cossey, are shown at their home on Kellems Lane, Scott Valley, in 2002. Charles works for the City of Yreka, as interim manager of the sanitation department. Nina is an accomplished seamstress, and enjoys crafts. She has won many blue ribbons at the Siskiyou County Fair, including two best-of-show. Crystal has musical talent and is taking piano lessons and loves horses. (Courtesy Nina Cossey.)

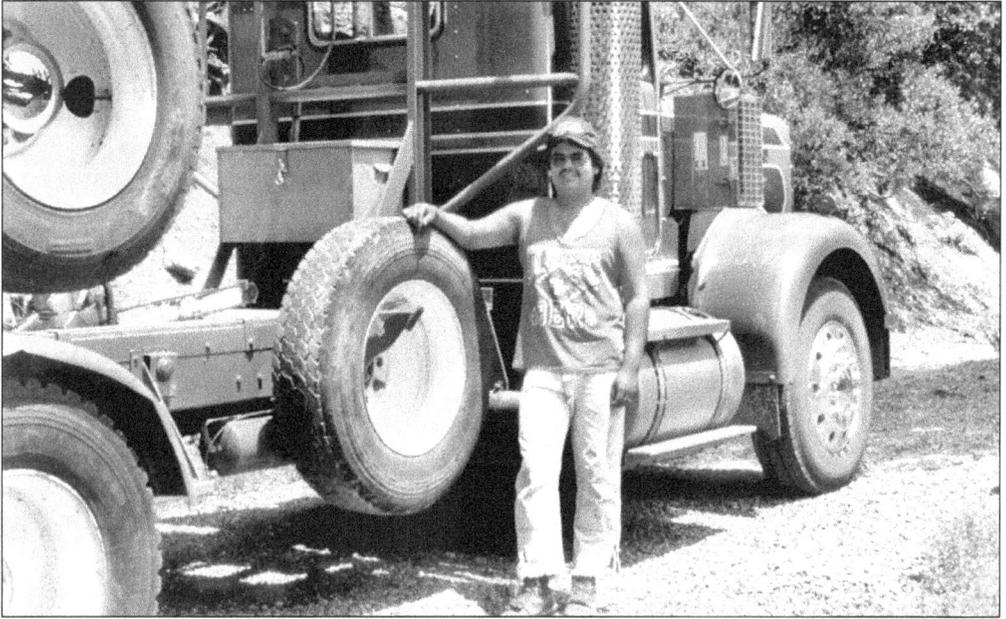

Glenn Hall stands in 1993 with the logging truck he drove for Vernon Gilmore. Now he drives for Peters Truck Lines. Glenn hauls a variety of large equipment all over the Pacific West on a low bed. Sometimes he runs a belly dump and hauls rock, gravel, and asphalt locally. He felled timber for several years with his brothers Roy and Bill. (Courtesy Glenn Hall.)

Renae, Glenn, Julie, and Carolyn Hall spend a relaxing weekend on the Salmon River in front of a Shasta Indian house at Forks of Salmon, California, in 2004. The Shasta Indians made these houses out of split cedar planks. They split the logs using an antler for a wedge. Carolyn is a part time crafts instructor for 30 students at the Fort Jones Elementary School. (Courtesy Glenn Hall.)

Bill Hall and his sister Linda's truck are shown here in 2002 at his shop in Yreka. Bill has his own Peterbilt truck and long hauls potatoes and other cargo in the winter. In the summer months he hauls gravel, asphalt, and pumice with his belly dump. He felled timber for several years before he went into trucking. (Courtesy Betty Hall.)

Tom Hall is shown here at the Flat Head Indian Reservation Vocational School in Montana. He studied diesel mechanics. Tom completed an 18-month course in 8 months, and graduated in 2003. In January 2004, Tom and his girlfriend Sara went to Laramie, Wyoming, to continue his education. Tom will graduate from school there in September 2004. (Courtesy Brenda Brodmerkle.)

Jessica Hall, graduating from the eighth grade at the Seventh-day Adventist School in Yreka, California. At her graduation, when she listed basket weaving as her hobby, the school's principal said, "They still do that?" Jessica's aunts, Linda and Mary, are taking Jessica and Julie Hall to a basket weaver's convention on the Oregon coast. The Shasta Indian culture lives on, and what a wonderful hobby. (Courtesy Tracy Hall.)

From left to right are Bill Hall, Tracy Hall, Benjamin Christ, Saundra (Hall) Christ, Betty Hall, and Roy Hall Sr. This wedding took place in 2002 at the Miner's Inn Convention Center in Yreka, California. Ben, and Saundra live in Redding, California. Saundra is studying nursing at the Shasta College. Ben is employed there locally. When Saundra graduates, Ben will start college. (Courtesy Betty Hall.)

Saundra Christ, Emily Christ, and Tracy Hall are at Betty Hall's home in April 2004. Saundra is Betty's granddaughter. Emily is 11 months old. Saundra gave birth to a boy in July 2004 and plans to finish her nursing degree at Shasta College. Tracy Hall is a respiratory therapist at the Fairchild Medical Center in Yreka, California. (Courtesy Betty Hall.)

Joe and Jessica Brodmerkle are seen here with their children Cory and Aaron in 2003. When Joe and Jessica had been married for seven months, Joe broke his neck logging and was totally paralyzed. Six weeks later Joe walked out of the hospital and was soon back in the woods. Joe told his grandmother Betty Hall that he thought about Nina Cossey and her achievements, and that Betty always told her family to "Never say, *I can't*." (Courtesy Jessie Brodmerkle.)

Jonathan, Amanda, Roy, Angie, and Vendala Brodmerkle are shown here in 2003. Vendala has had three open-heart surgeries. Today she is strong and full of energy. Roy is self-employed, and Angie is currently a stay-at-home mom. They live in Montana near Roy's parents. They recently went to Disney World through the Make-A-Wish Foundation. (Courtesy Angie Brodmerkle.)

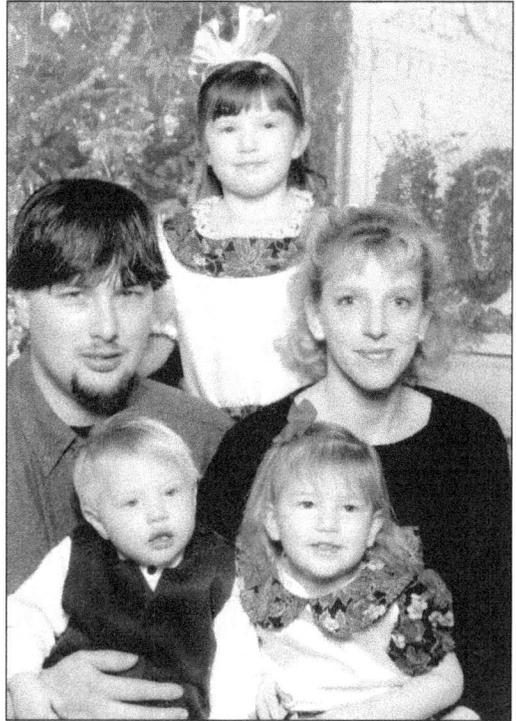

Vicente Navarro, Elexio Torres, and Victor Navarro go fishing at every opportunity and they carry their poles when they travel just in case they spot a fishing hole. This photo was taken in 2002 on the Sacramento River, at Redding, California. The boys and grandpa are doing what they enjoy most, telling stories, getting their lines wet, and reeling in some fish for dinner. (Courtesy Linda Navarro.)

101

Here are Victoria (Navarro) Haenggi and her son Elexio Torres *c.* 1992. Vickie is the daughter of Linda (Hall) and Victor Navarro. Linda worked for California Rural Indian Health Board for 26 years. She quit and will be the director of members' services and marketing for the Turtle Health Plan, the first American Indian-owned HMO in the U.S. Victor is a lithographer and a medical illustrator. (Courtesy Linda Navarro.)

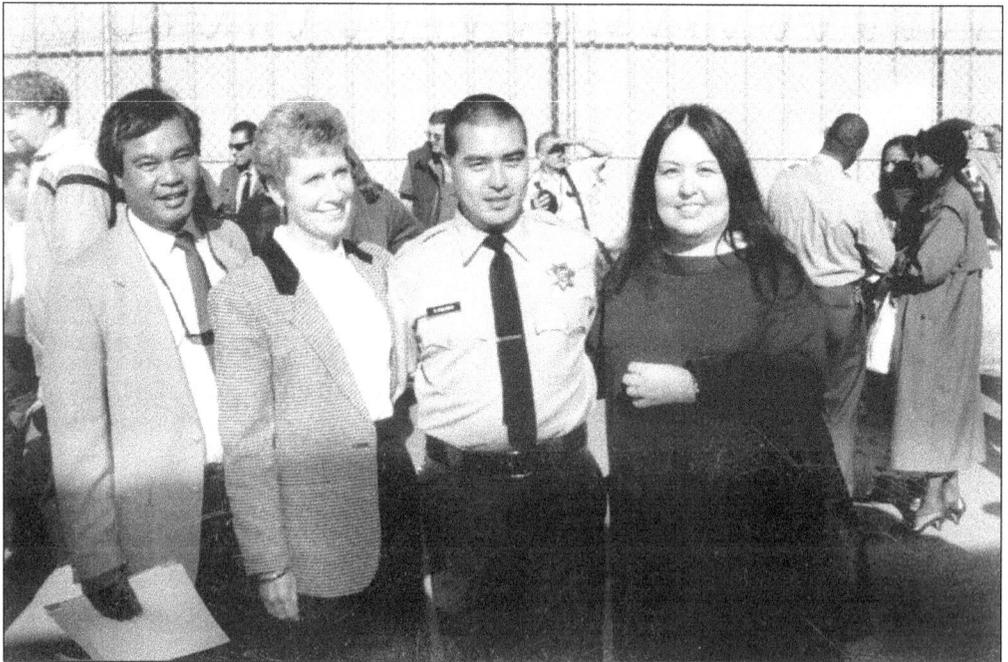

Victor Navarro, Ann Platt, and Ryan and Linda Navarro are seen here in 1995 at the graduation of Ryan from the police academy at Lodi, California. Ms. Platt was Ryan's counselor when he was in high school, and he gave her the honor of putting on his badge. Today Ryan is a prison security guard and transports prisoners. (Courtesy Betty Hall.)

Serena Navarro, Ryan Navarro (a clown), and Judy Barney are at Serena's first birthday party in April 2004. It looks like they had a good time. They live in Sonora, California. Ryan is the grandson of Roy and Betty Hall. (Courtesy Linda Navarro.)

Richard Haenggi, Elaina Haenggi, Vicente Navarro, and Elexio Torres, pictured here in 2003, are the grandchildren of Victor and Linda Navarro. They live in Sacramento and eagerly await trips north to see their great grandparents, Roy and Betty Hall. They get to hear stories about their parents and grandmother Linda and old Shasta tales. Once they spotted a panther (mountain lion), and that gave them a story to tell their friends back home. (Courtesy Linda Navarro.)

This is Lars and Stephanie (Jones) Carpelan's wedding picture from 2002. They were married in the decorated front yard of Lars's grandparents Roy and Betty Hall. Lars is the son of Eric and Mary Carpelan. Stephanie's family lives in the Sacramento Valley; the couple lives in Yreka. (Photo by and courtesy Victor Navarro.)

Hadrian, Damian, Lars, and Stephanie Carpelan sit for a family portrait in 2004. It wasn't easy to get the boys to sit still long enough to take this picture. Lars is employed at Raleys in Yreka and Stephanie is attending College of the Siskiyous, studying nursing. (Courtesy Stephanie Carpelan.)

Theresa (Titus) Sargent, shown here in the 1920s, was the great granddaughter of Chief Shasta, (aka Shastika). Theresa married Richard (Dick) Sargent. When he brought her home, Mugginsville was atwitter with the news that Dick married an Indian woman! Theresa threw a party, and she told her guests to bring a song or story. Well, they came and just sat around with their mouths open and stared. I guess so, isn't Theresa beautiful? (Courtesy Richard Sargent.)

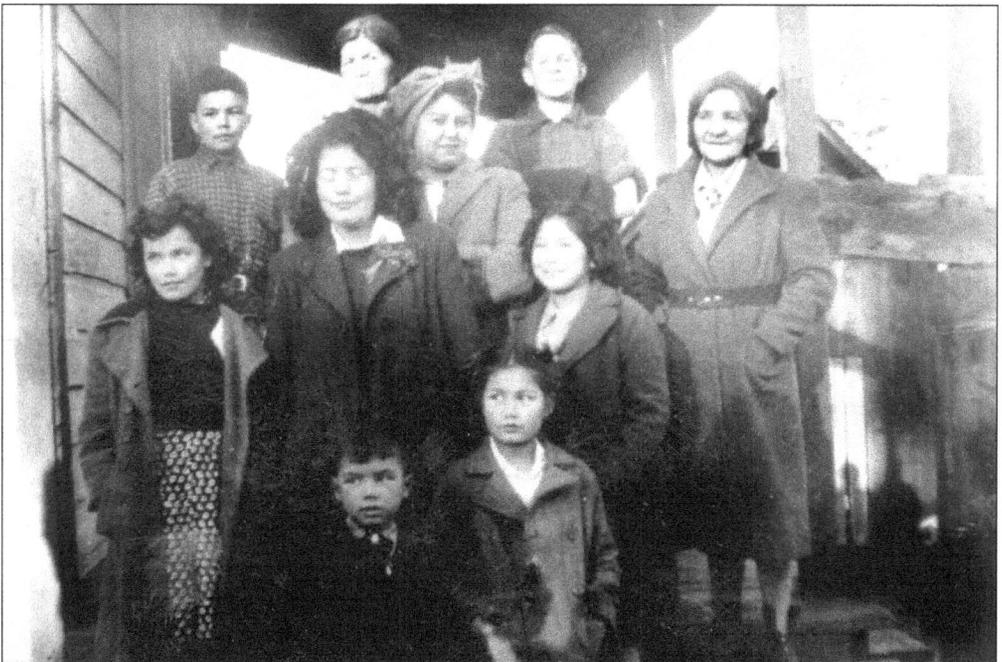

Theresa Sargent was a minister of Assembly of God Church and lived in Mugginsville. She started having Sunday services in the one-room Quartz Valley School. Shown left to right are (front row) Robert McCallister, Elda Hall; (second row) Laura Hall, Virginia Hall, Betty Lou Wicks; (third row), Roy Hall, Nina Wicks, Clara Wicks; (back row) Mandy McCallister, and Don Ricky. (Courtesy Richard Sargent.)

From left to right are Roy Hall, Richard Sargent, and Fred Wicks Sr. (driving) on the Quartz Valley Shasta Indian Reservation tractor. They were pulling in logs to build the Charity Mission. Theresa Sargent initiated the project and church members all helped to build the church. (Courtesy Roy Hall Sr.)

The Charity Mission is a hand-built log church, seen here c. 1948. Theresa spoke about how God healed. Once Theresa looked at Nina Wicks, who was paralyzed and confined to a wheelchair after a horse smashed her pelvis. Theresa went to Nina, anointed her with olive oil and said, "Nina rise up and walk, in the name of the Father, Son, and the Holy Spirit!" Nina stood up and walked. (Courtesy Betty Hall.)

Theresa Sargent and her children are pictured here, from left to right: Maureen Wilson, Colleen McCallister, Sharon Iverson, Roland Sargent, Richard Sargent, and Barbara Smoot. Theresa traveled the county with Colleen, Richard, and Sharon, preaching the gospel. Richard said it was a wonderful experience. Richard and Barbara still live near the Charity Mission. Colleen lives in Yreka. This photo was taken at the Charity Mission on Quartz Valley Shasta Indian Reservation in the 1970s. (Courtesy Richard Sargent.)

Richard Sargent took a troupe of Shasta Indians on tour to Australia c. 1975. He is wearing a snakeskin headband, and a necklace of bear claws and shells. Richard Sargent is the son of Theresa and Dick Sargent. He worked for North American Aviation, which was taken over by Rockwell, where he worked until he retired. Richard was executive director of the Tribal Academy of Performing Arts, located at Columbia Studios in Hollywood, California. (Courtesy Richard Sargent.)

Frank and Maureen (Sargent) Wilson, shown here in the 1960s, made their home in Yreka. They have one son, Frank Wilson Jr. Maureen is Theresa Sargent's daughter. Frank is Mandy McCallister's son. Maureen and Frank worked hard to help build the Charity Mission. At times Maureen would give the sermons for her mother. Frank Jr. worked for Lloyds of London and Indian Health. (Courtesy Betty Hall.)

Theresa Sargent plays her guitar and sings in the 1980s. Members of the Sargent family are very talented musically, sang wonderfully, and were dynamic ministers of the gospel. Colleen has a beautiful voice. Because Nina Wicks was healed through Theresa's ministry, Theresa was a very special person in Betty's life. (Courtesy Richard Sargent.)

Three

SALMON RIVER

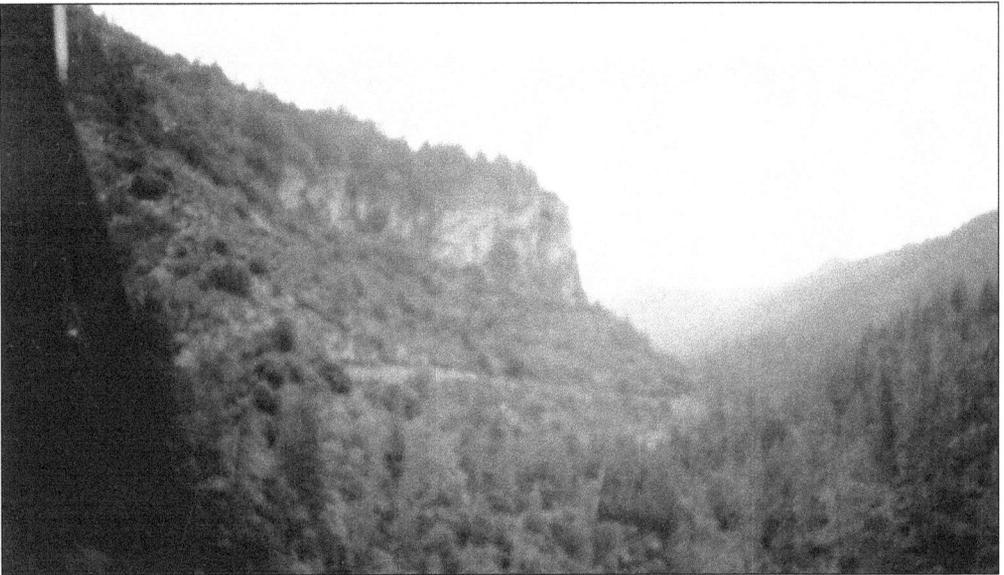

Chief Shastika's village was in Shasta Valley. He was captured and led away in chains to Fort Miller at the headwaters of the San Joaquin River in 1851. His daughters Kate and Julia fled south with Canyon Mary, a very old woman at that time. A short while later they escaped from an Indian hunting party that was mistreating them by traveling the South Fork of the Salmon River. They headed toward the Jordan Ranch. Josiah Jordan found them hiding and took them to his ranch; Kate was 16. (Courtesy Betty Hall.)

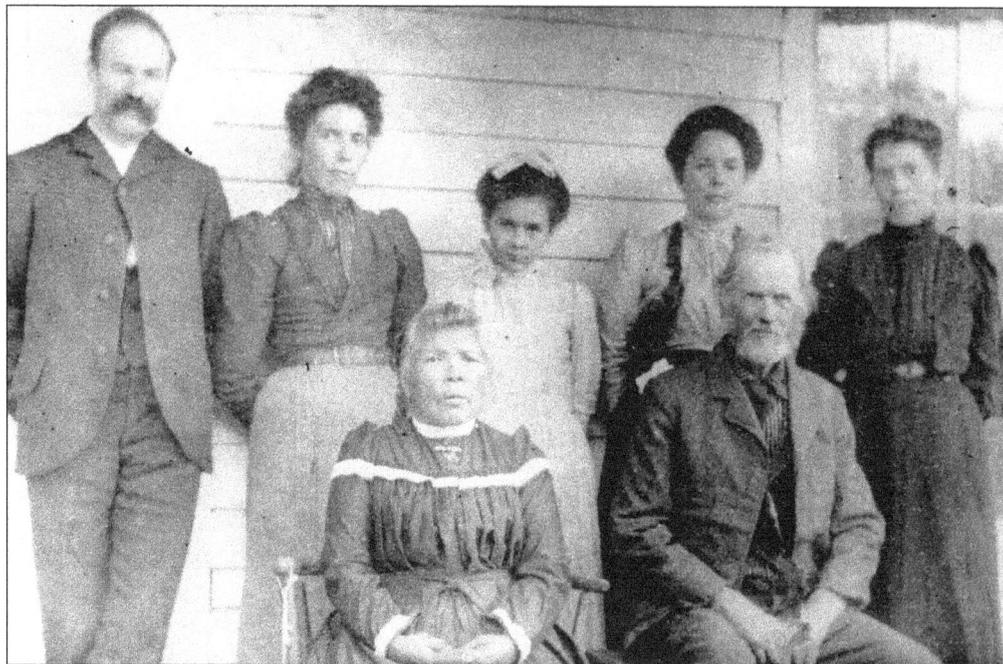

Seated here are Kate, daughter of Chief Shastika, Blaze, and Josiah Jordan. Standing left to right are Choncy Thompson, Pauline (Jordan) Tinny, Rose George Tickner, Cora Jordan, and Annie Jordan. After Josiah rescued Kate and Julia, some Indians tried to kill them for living with whites, and Karuks tried to kidnap them because they were the chief's daughters. They hid in limestone caves and Canyon Mary brought them food. Kate was born in 1845 and died in 1910. (Courtesy Bernita Tickner.)

These are the children of John and Ada May (George) McBroom in the 1940s. From left to right they are Francis (Dove) McBroom, Henry (Wook) McBroom, Ella (Gabe) McBroom, Earle McBroom, and John (Nel) McBroom. (Courtesy Jeanie Griggs.)

110

Charlie Lake is shown here holding Oscar and Ozie in the 1920s. Just to his right is Beulah. In the back row, left to right, are Wesley, Claris, Hazel, Clara, and Cleo Lake. Charles Lake is the grandson of Josiah and Kate Jordan. The family lived on Blue Ridge, in the Salmon River area. (Courtesy Bernita Tickner.)

Ada May George, shown here, married John McBroom. They lived on the Salmon River. She was the granddaughter of Kate and Josiah Jordan. (Courtesy Jeanie Griggs.)

Shilo Griggs, daughter of Jeanie (McBroom) Griggs, is pictured here at the age of four, on her painted pony, Nancy. She rode her horse all the time and she insisted on riding alone in the Etna Rodeo Parade, but allowed her mom to walk along. This was taken in May 1990. She won first place in the youngest mounted division and the special entry award. (Courtesy Jeanie Griggs.)

Shilo Griggs and Ellie Pynes are getting ready to perform for the Etna Rodeo in the drill team. Shilo rode in the drill team for nine years and never tired of the practice it took to get and keep the patterns smooth and flowing. Her big grin and ready laugh kept the group going even when the days were hot and the horses were less than cooperative. (Courtesy Jeanie Griggs.)

This is Shilo Griggs graduating from Etna High School, June 2003. Shilo received several scholarships, including the Robert McCallister Memorial Fund for Native American students. She overcame a debilitating auto accident and returned to school to graduate. Shilo died January 2004. Robert Hall was a classmate and will always remember her quick wit and generous spirit. She will be missed. Shilo Josie Griggs, June 22, 1985–January 10, 2004. (Courtesy Jeanie Griggs.)

Jeanie Griggs is shown here at the wedding of half brother Richard George and his wife, Janice, on June 27, 1992. Jeanie is the daughter of Earle McBroom and Marge McBroom George and lives in Etna, California. Her children are Tanner, Flint, and Shilo. (Courtesy Jeanie Griggs.)

Shown here from left to right are (front row): Cheyenne Rice, Kate (George) Rice, and Marge George; (back row) Erik Rice, Crystal Rice, and Dave George. Dave and Marge owned the Forks of Salmon store for many years before retiring to Montana. Dave passed away a few years ago. Eric works in construction. (Courtesy Jeanie Griggs.)

These are the great-great grandchildren of Chief Shastika and Blaze, at the first-ever reunion of the Jordan family on the south fork of the Salmon River, July 14, 2001. From left to right are Evelyn Jones, Harry Lake, Pauline Colby-Pennel, Mamie E. Tickner-Smith, Chet McBroom, Ida George Cappello, unidentified, Claire George, Robin George, Wayne Bartley, and Tom Tickner. (Courtesy Wayne Bartley.)

114

These are the great-great-great grandchildren of Chief Shastika and Blaze at the Jordan Ranch, July 14, 2001. Behind this building there was a cabin where Canyon Mary lived for many years. She was very, very old and looked like a mummy. Her mind was lost so they built a fence to keep her from wandering off. (Courtesy Wayne Bartley.)

The great-great-great-great grandchildren of Chief Shastika and Blaze are shown here on July 14, 2001. Kate and Josiah Jordan are buried nearby in a small family cemetery. This was a very old, very large village site before the white miners arrived in the 1850s, and the family still protects their current and ancient burial grounds. (Courtesy Wayne Bartley.)

Shown here from left to right are Frank Bartley, David Bartley (kneeling), Ava Cramer, and Wayne Bartley. Ava returns to her birthplace at the Jordan Ranch to find the grave of her mother, Cora Flora Jordan, and place a headstone on her unmarked grave in 1982. Her last trip out of the ranch was by horseback as a five-year-old child, to take her terminally ill mother to Moffett Creek. (Courtesy Wayne Bartley.)

Boston, Amber, Margaret, and Charles Nichols are shown here from left to right at Amber's graduation from Etna High School, June 2003. Amber received several scholarships including the Robert R. McCallister scholarship for Native Americans. The family splits their time between Etna and Salmon River. Margaret works for the Salmon River Volunteer Fire Department and is the great-great-great granddaughter of Chief Shastika and Blaze. (Courtesy Jeanie Griggs.)

Shown here from left to right are Henry and his son Glenn McBroom, standing with Andy McBroom and his father Earl McBroom. They have been hunting geese. This family gets out and hunts or fishes all year long. They live as traditionally as they can when it comes to hunting game, from venison to fish to geese. (Courtesy Sharon McBroom.)

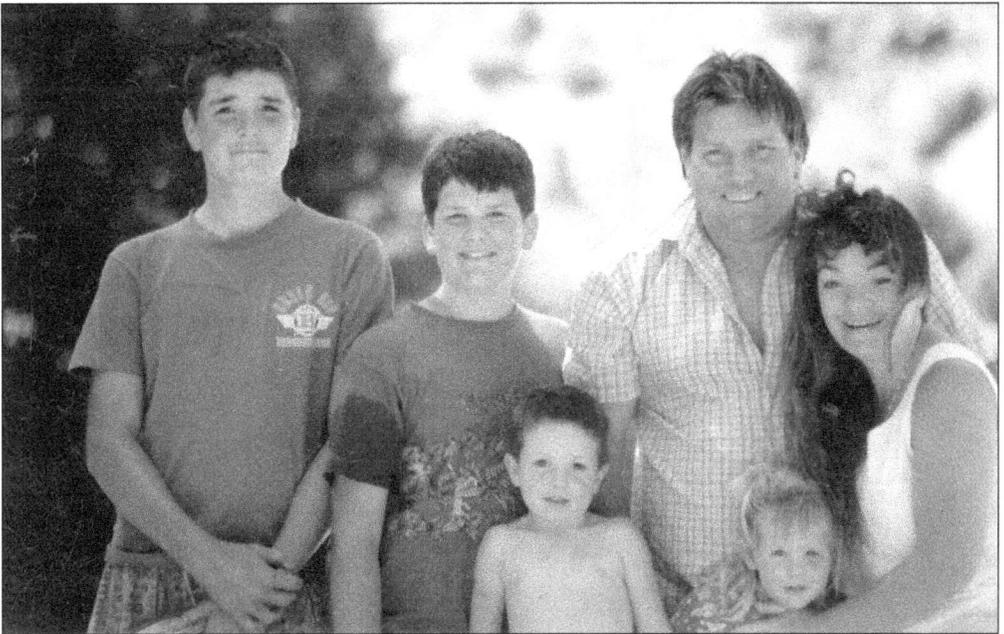

Henry, Tilly, Sharon, Terkle, Wyatt, and Glenn McBroom are pictured here from left to right. Glenn works in the logging industry and Sharon works for a display technician at Wal-Mart. (Courtesy Sharon McBroom.)

Pictured here, from left to right, are Kay (Hoop) George, David George, Bebee George, Claire Zann, Janean, and cousin Ricky George. Many of the family still live on the Salmon River and some still hold Shasta Indian allotments. "Hoop" was employed by the U.S. Forest Service and led a campaign to have the creeks in our area that are named "*Squaw*," which means "vagina" in Chinook jargon, changed to "*Taritsi*," which means "woman" in Shasta. Thank you, Hoop. (Courtesy Jeanie Griggs.)

Nate McLaughlin graduated from St. Mary's College in Moraga, California, on May 22, 2004. He made the dean's list his last two semesters. Nate will be taking a phlebotomy class in June 2004, and working at that for a year. Hopefully he will be able to attend medical school in the fall of 2005. Keep up the good work, Nate. (Courtesy Johnnie "Mitzie" McLaughlin.)

This photo of Ellen Brazille Grant and Dean Langford was taken February 22, 1920. Ellen was the daughter of Queen, who was the daughter of Konomihu Chief Mawima and a Rogue River Shasta Indian. Frank Brazille was French and Cherokee, and taught his wife, Queen, to sing songs in Cherokee. Ellen's brothers were Peter and Logan Brazille and her sister was Susan (Brazille) Grant. (Courtesy Harry Lake.)

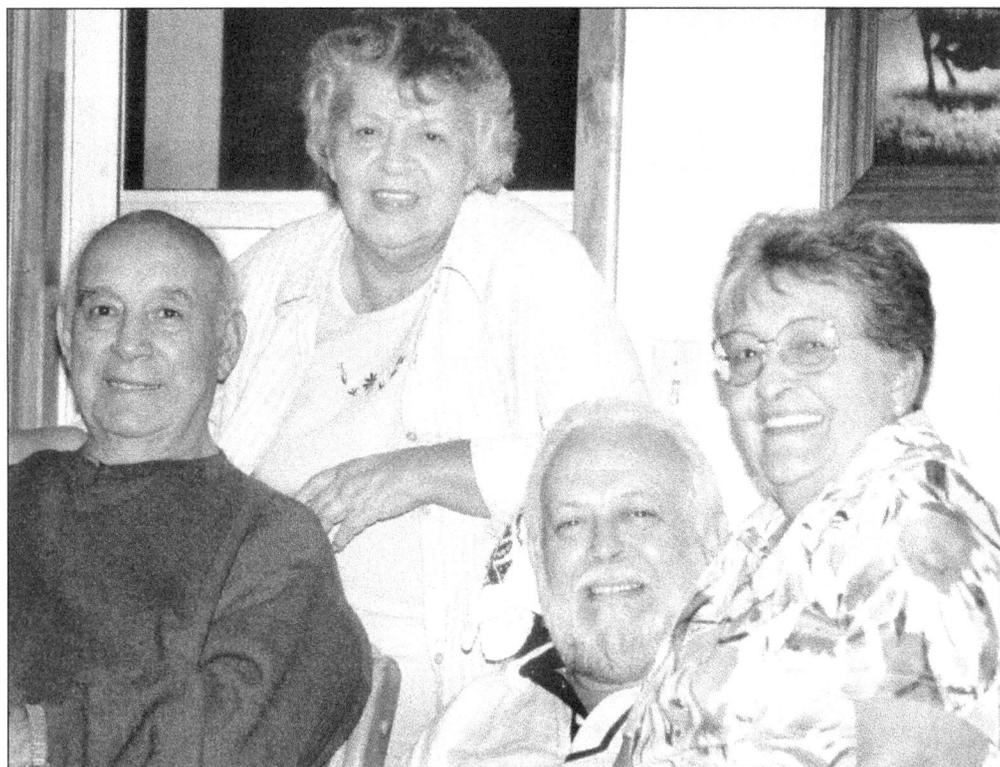

Shown here from left to right in 1999 are Joe George, Evelyn Jones, Harry Lake, and Ida Cappello, all brothers and sisters. Joe was a diesel mechanic in Hawaii. Now he is 84 years old, and not very well. Evelyn worked as a nurse at the Siskiyou General Hospital. Harry was a surveyor. Ida made many fine handicrafts, leatherwork, and needlecraft, but she says she does very little now. (Courtesy Harry Lake.)

This is Susan Brazille and Shade. Susan is from the Salmon River and is an ancestor of Robert Grant. Her parents were Frank Brazille and Queen. Susan did extensive work with ethnographers on the Shasta language. Her sister was Ellen Grant, the grandmother of Robert Grant. (Courtesy Harry Lake.)

Robert Grant, in the 1990s, shows one of the Shasta drums he makes. Robert's father, William (Bill) Grant, worked in the woods felling timber with Lee Wicks. They were close friends and attended Sherman Indian School in Riverside, California. Robert's mother was Dorothy Albers. Robert lived three years with Roy and Betty Hall as a child. Betty says he was a pleasure to have in their home. (Courtesy Robert Grant.)

120

Kelly and Harry Lake are shown here in May 2004 in Betty Hall's front yard. Harry is a descendent of Chief Shastika. The Lake family is from Salmon River. Harry has been away for some 50 years, working as a surveyor in the Pacific Northwest. Since retirement he has been living in Montague, California, where Kelly works as a caregiver to the elderly. Betty and Roy are delighted that they are near. (Courtesy Betty Hall.)

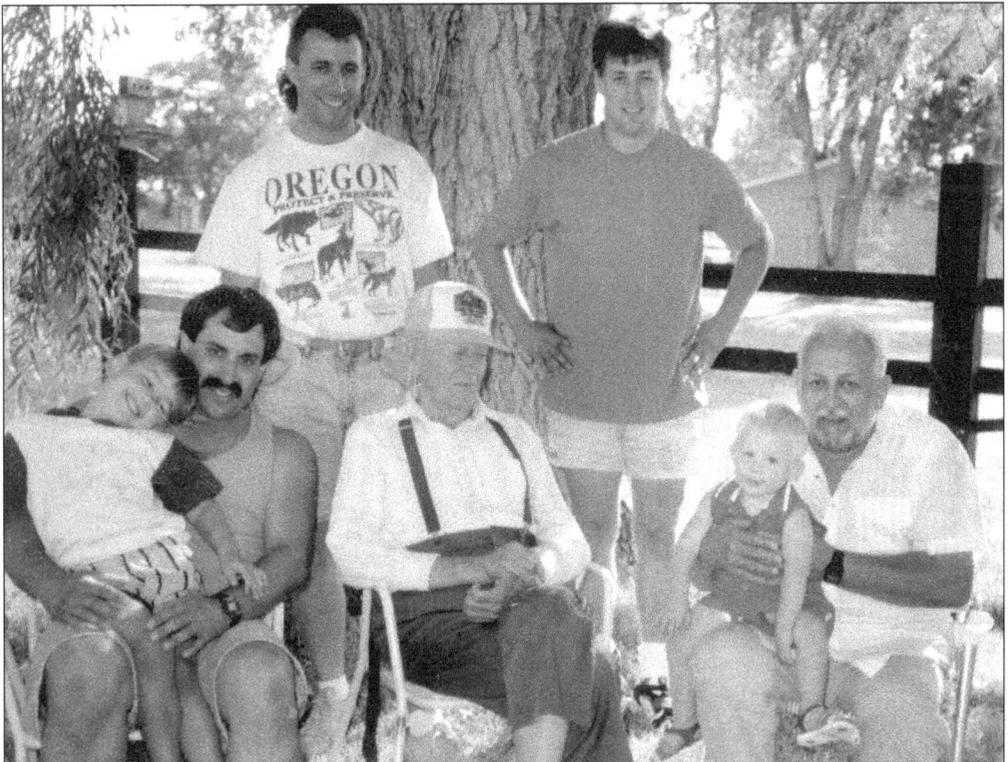

Sitting in this August 1984 photo, left to right, are Tyler Lake, Greg Lake, Wesley Proctor Lake, Byron Lake, and Harry Lake. Standing are Gary Lake and Glen Lake. (Courtesy Harry Lake.)

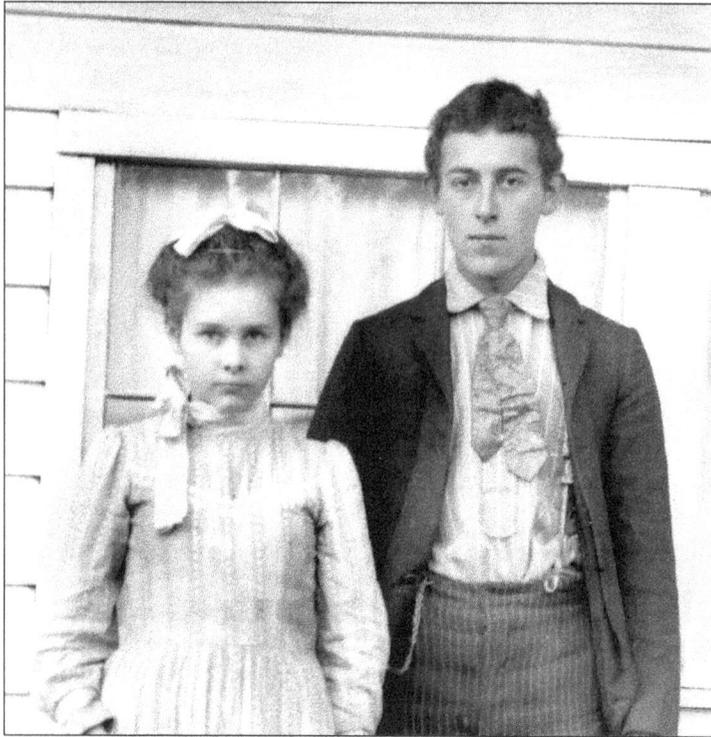

Rose Ella George and her brother Willie George are pictured here in the Cecilville area *c.* 1914. Rose Ella married William Lankford Tickner. Rose Ella was the daughter of Thomas George and Ella E. Jordan, who was Kate Jordan's daughter. She had two children, Thomas and Mayme. (Courtesy Bernita Tickner.)

Ada McBroom in her later years is photographed in February 1952 with her son Henry McBroom. (Courtesy Henry McBroom.)

Shown here from left to right are Ella Elizabeth George and her daughters Hazel Lake, Ada George, Rose Ella George, Tinna, and Annie? This picture was taken at Cecilville, California. (Courtesy Bernita Tickner.)

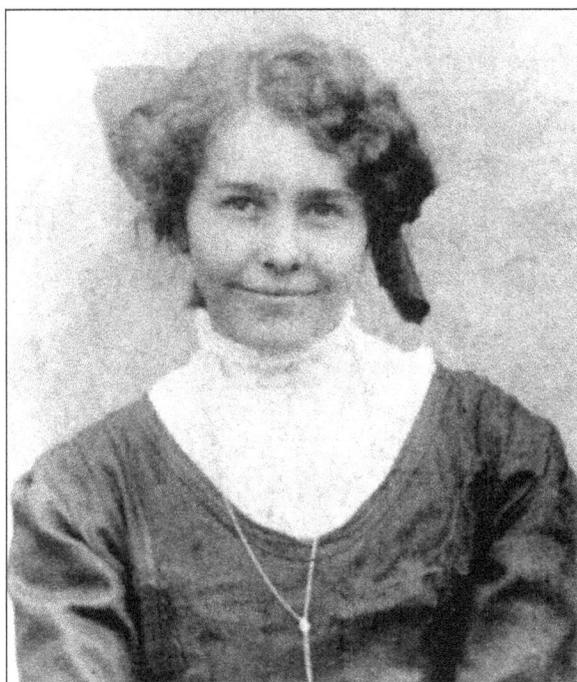

Rose Ella (George) Tickner is shown here as a young woman c. 1918. Her son Tom Tickner was born December 16, 1920, near Etna, and later Mamie was born. When Tom was four, Rose died three days after she was stricken by paralysis. They were living in Sawyers Bar. The children moved in with their grandmother, Ella George, in Cecilville. Rose was born June 13, 1892, and died November 1924. (Courtesy Bernita Tickner.)

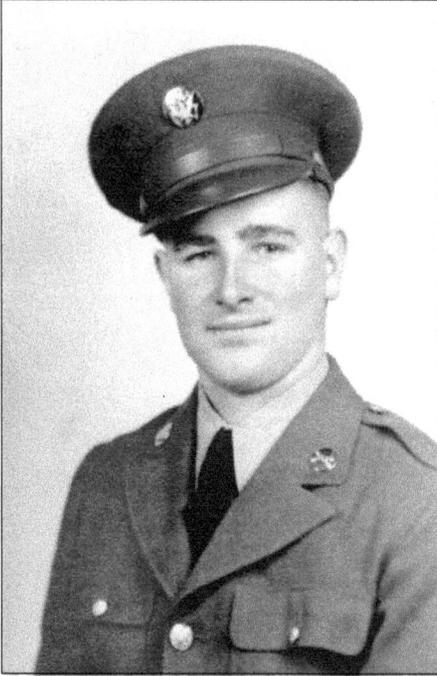

In Tom Brokaw's book, *The Greatest Generation*, Tom Tickner is holding the flag in the picture of troops capturing a German flag. He has five battle stars. He was discharged with a T-4 rating as a technical sergeant, the first commander of District 2 from the Perry Harris Post of the American Legion. He was Grand Marshall of the third Veteran's Day Parade in Etna. This photo is *c*. 1944. (Courtesy Bernita Tickner.)

Tom Tickner is photographed here with the tank he drove during World War II. On the day after D-Day, Tom dove his tank into the water, and made it safely onto Utah Beach. Death was everywhere. Tom fought through all the major battles on the European front. At one time he climbed out of his tank to answer nature's call, and a bomb struck it and killed his crew. (Courtesy Bernita Tickner.)

124

Shown here from left to right are Charlie Roff, Elena Florence Roff, and Johnny, Lewis, Lester, and Clifford Roff at the old Cecilville Store. This is Bernita Tickner's family. They are of Karuk descent. Bernita married Tom Tickner and they had four sons: Raymond, Gary, Bill, and Arnold. Tom worked on the Yuba Dredge and then became a timber feller. (Courtesy Bernita Tickner.)

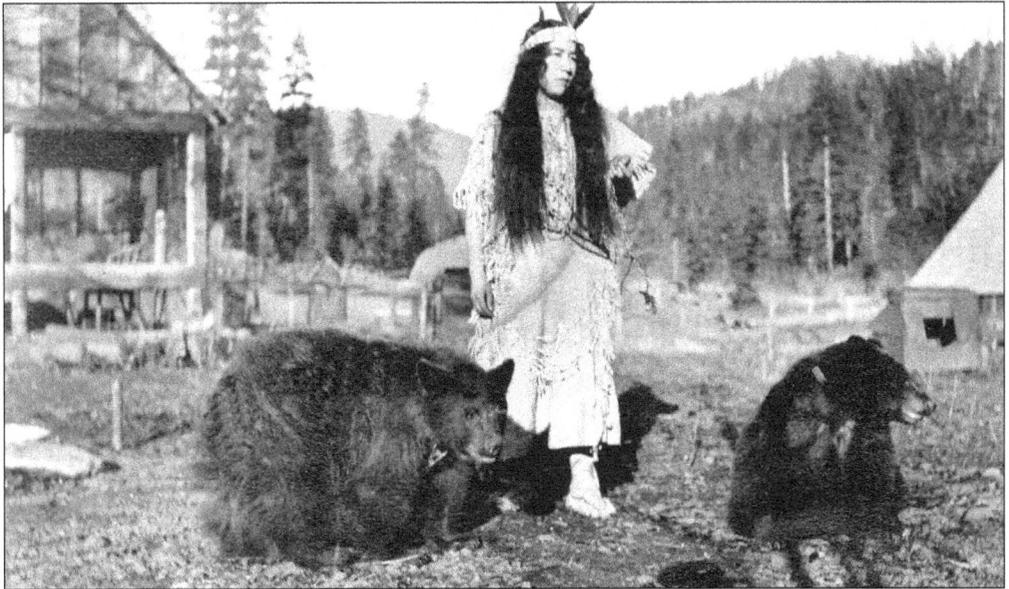

Carrie Wicks is dressed in buckskin here c. 1900. She was a traditional tanner and then later attended a school of taxidermy in Chicago. She worked on ranches cooking or on hay crews and was in Oro Fino when she became ill and died. She left a son, Thomas H. Webster. Clara Wicks raised him. Her brothers often killed the mother bears and mountain lions and brought home cuddly little animals, but they grew big. The mountain lions were sold to the circus. (Courtesy Betty Hall.)

Indian Peggy, the wife of old Chief Tolo of the Shasta Tribe, is pictured above. They lived in the vicinity of Hawkinsville, California. Indian Peggy was honored for warning the towns of Yreka and Humbug of an impending Indian attack in 1851, but the reason why they planned the attack is not mentioned. Two miners had kidnapped, raped, and killed a Shasta Indian girl. The girl's brother witnessed the deed and returned to his village nearby and told his people. An attack was planned, but Peggy realized that the miners would slaughter them all if the attack took place. She went to the towns and warned the miners. When the Indians arrived, there was no one around. The miners had gone into their mining tunnels to hide. The Indians returned to their villages. Shortly after that a group of miners attacked a village south of Yreka and slaughtered the entire population of the village. Shown below is Indian Peggy's headstone, dedicated by the Siskiyou County Historical Society on June 9, 1951, to commemorate her bravery. The lady standing by the headstone is Mandy Clarkson, a descendent of Peggy. (Courtesy Siskiyou County Historical Society.)

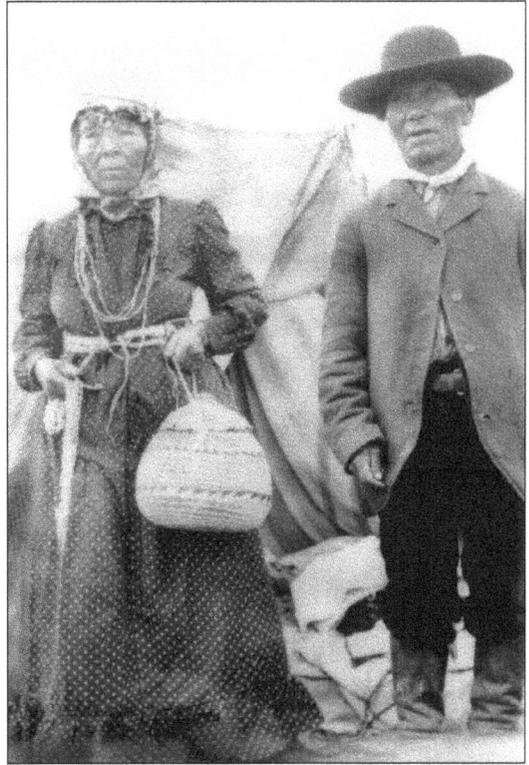

This is a photo of Susan and Jake Smith. He was also known as Moffitt Creek Jake. Note Susan's pretty basket handbag. They lived in a type of covered wagon, and when they wanted to go to the Bender allotment, they just hitched up the horse. Jake built a roundhouse at Bogus on the Klamath River, for a Ghost Dance. Jake lived to be 110 years old. The Ghost Dance was a religion started by Walker Lake Paiutes in the 1870s, spreading the message that dead Indians would return to the living and the white people would disappear. Although the Shasta received the message from the Modocs, and in turn took it to the Siletz and Grand Ronde Reservations, they did not embrace it for long. It only brought more hardship on their people, as the secret meetings of the Ghost Dance threatened the whites, who feared an attack. (Courtesy Siskiyou County Historical Society.)

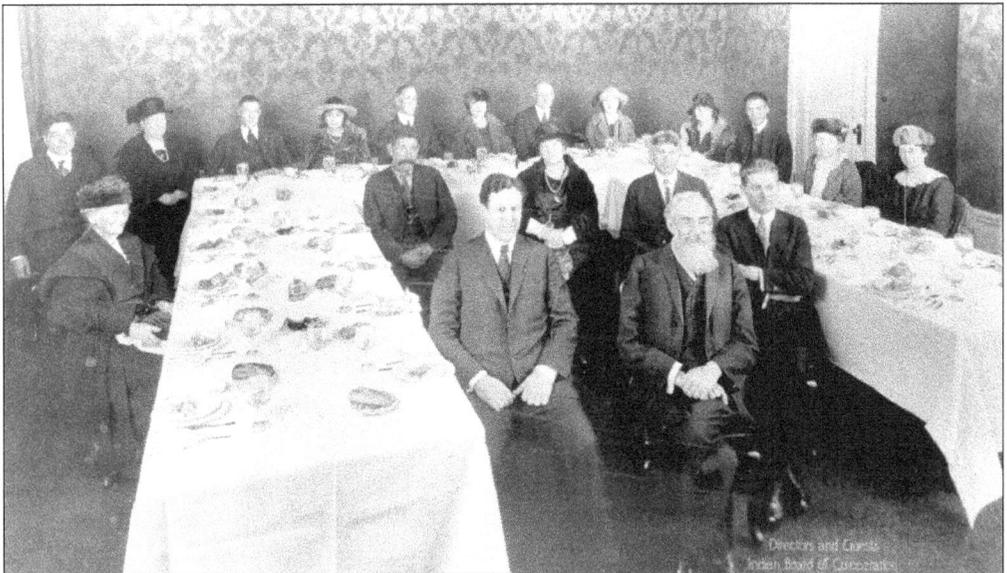

John Carmony, a Shasta Indian, was a member of the Indian Board of Co-operation that traveled to Washington D.C. in 1923, petitioning for compensation for land taken from the Indians. Fred Collette is in front with a white beard. John Carmony, with a moustache, is seated at the inside left corner. The California land payments of $150 and $600 resulted. Millions of dollars still remain to be paid. (Courtesy Betty Hall.)

127

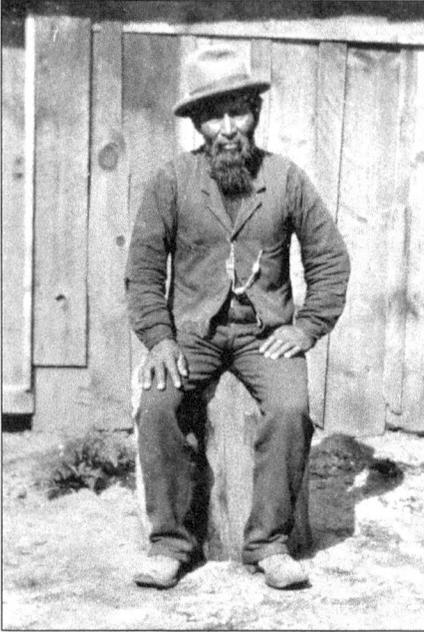

This is Indian Charlie, an Okwanuchu Shasta from the village on Indian Lane near Mount Shasta City. Charlie's wife was Indian Peggy, a medicine woman not to be confused with the Yreka Indian Peggy. Lucille Morgan, who spoke to Betty Hall when she was an old woman, escorted guests from the resort to the village where the Indians sold baskets when she was a young girl. Indian Jim was the last person living in the village, and he died of smallpox, so Lucille's father burned the last buildings. (Courtesy Betty Hall.)

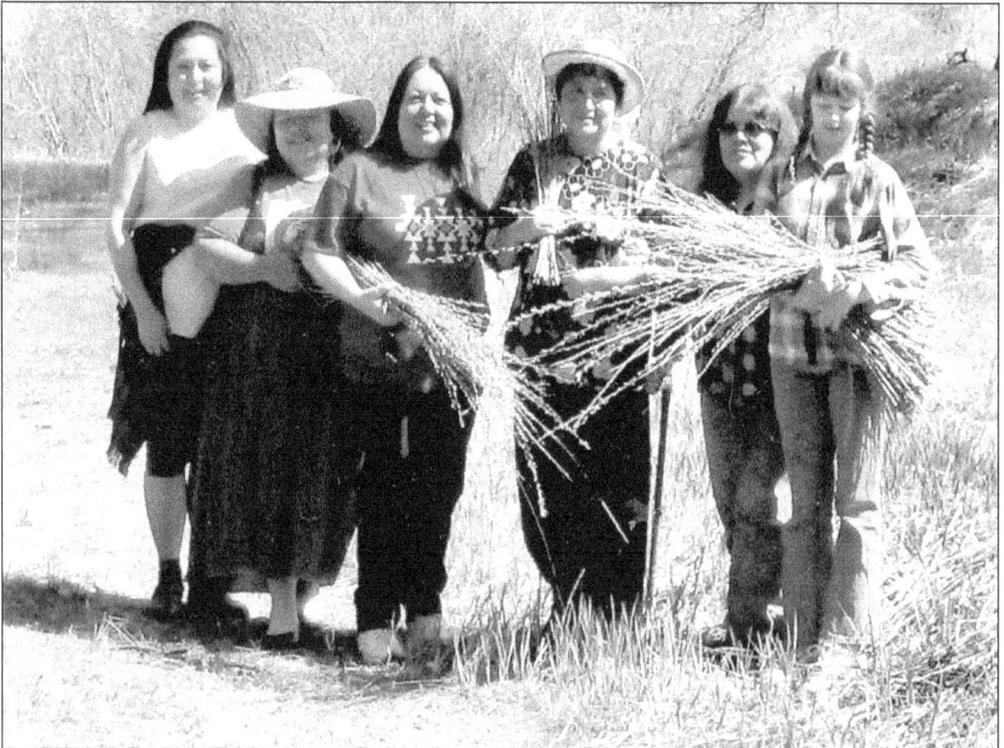

Brenda Brodmerkle, Linda Navarro, Mary Carpelan, Betty Hall, Nina Cossey, and Crystal Cossey have been picking willows for basket making at Grandma Mandy's willow patch on the Scott River in May 2004. Mary and Linda are the basket makers and Crystal is an apprentice. In June Mary and Linda go to the annual basket weavers' convention. This year they took nieces Julie and Jessica Hall. (Courtesy Betty Hall.)

www.ingramcontent.com/pod-product-compliance
Lightning Source LLC
Chambersburg PA
CBHW050659150426
42813CB00055B/2339